Finding Birds in Orkney

Harold Stiver

Finding Birds in Orkney

Copyright 2014 Harold Stiver

All rights reserved. No part of this book may be reproduced in any form or by any electronic or mechanical means including information storage and retrieval systems without permission in writing from the author, except by the reviewer who may quote brief passages

ISBN#978-1-927835-17-3

Dedicated to Anne and Mike Phillips, good friends

Table of Contents

Introduction	Pg 5
Rare Bird Alerts	Pg 5
Photo Credits	Pg 6
How to use this book	Pg 7
Map of Orkney	Pg 8
Orcadian Bird Names	Pg 9
How to Get there	Pg 11
How to get around	Pg 12

The RSPB Reserves

Birsay Moors, Mainland	Pg 14
Brodgar, Mainland	Pg 16
Cottascarth & Rendall Moss, Mainland	Pg 18
The Loons & Loch of Banks, Mainland	Pg 19
Marwick Head, Mainland	Pg 20
Hobbister, Mainland	Pg 22
Hoy	Pg 23
Mill Dam, Shapinsay	Pg 25
Trumland, Rousay	Pg 26
Onziebust, Egilsay	Pg 27
Noup Cliffs, Westray	Pg 28
North Hill, Papa Westray	Pg 30
Copinsay	Pg 31

Other good sites

Birsay, Mainland	Pg 32
Skaill, Mainland	Pg 33
Castle O'Burrian	Pg 34
North Ronaldsay	Pg 35
From the Ferries	Pg 36

Self Guided Tours

Tour One- Searching for seabirds	Pg 37
Tour two- Marshes and Moors	Pg 40
Tour Three- Wonderful Westray	Pg 44

Bird List Pg 46

Bibliography Pg 124

Index Pg 125

Introduction

I first visited Orkney in 1974 when I got married to my wife Elaine there. I loved the islands and the people who lived there immediately, and I have made many trips there since.
During that time I have spent a large amount of time exploring the islands and seeing the wildlife there especially the birds.

I have written this book in the hope it will be helpful to the new traveler to Orkney as well as more experienced visitor. For those new to Orkney I recommend the Self-guided tour instructions. They are designed to get you to some of the best birding sites with a minimum of hassle. For the more experienced who may have target species they wish to see, the information in the citations of the bird list should give them an indication of the best places to go.

There are 398 species accepted for Orkney at the end of 2012 based on the BBRC (British Bird Rarities Committee) This book includes basic information on all of these species but the visiting birder should have expectations of only a portion of this species with many being less than annual in occurrence. However there is often something rare to be found and there are resources under Rare Bird Alerts section which you might use to help you find them.

Rare Bird Alerts

Although many of the species in the Orkney list cannot be expected there are often rarities present. You can find out what is around and get location details by joining the the Yahoo group orkbird. It is located at:
http://groups.yahoo.com/group/Orkbird/
There are also bird apps available from Birdguides and RBA. There may be a fee but look also for free trials.
http://www.birdguides.com/home
http://www.rarebirdalert.co.uk

Photo Credits

All photographs are the copyright of the author Harold Stiver and may only be used with his written permission.

How to use this book

This guide is designed to be used in three main ways.

1) The first section deals with places to find birds, mainly RSPB areas, supplemented by additional destinations. Each area has a general description, information on how to get to it and a list of the birds that you might expect to find there.

2) The second section has three self guided tours. It is intended for those who may only have a few days and want to get a good overview of the different habitat and a range of species.

3) The third section is a systematic list of the species which have been recorded in Orkney. If you are targeting certain birds, you can look it up and get information on where and when it might be expected. It should also save you wasted time chasing birds which are not likely to be found due to rarity or season.

Map of Orkney

RSPB Reserves locations: North Hill (Papa Westray), Noup Cliffs (Westray), Trumland (Rousay), Onziebust (Egilsay), Marwick Head, Birsay Moors, The Loons, Cottascarth, Mill Dam (Shapinsay), Brodgar, Hobbister, Hoy.

Orcadian Bird Names

There are many interesting alternate names for birds in Orkney. Following is a list of some of them:

Rain Goose, Loom- Red-throated Diver, Gavia stellata
Immer Goose- Great Northern Diver, Gavia immer
Dabchick- Little Grebe, Tachybaptus ruficollis
Mallimack- Northern Fulmar, Fulmarus glacialis
Lyrie- Manx Shearwater, Puffinus puffinus
Storm Finch- European Storm Petrel, Hydrobates pelagicus
Solan Goose- Northern Gannet, Morus bassanus
Great Scarf- Great Cormorant, Phalacrocorax carbo
Scarf- European Shag, Phalacrocorax aristotelis
Sly-Goose- Common Shelduck, Tadorna tadorna
Stock Duck- Mallard, Anas platyrhynchos
Dunter- Common Eider, Somateria mollissima
Calloo- Long-tailed Duck, Clangula hyemalis
Sawbill- Red-breasted Merganser, Mergus serrator
Erne- White-tailed Sea Eagle, Haliaeetus albicilla
Kattakally- Hen Harrier, Circus cyaneus
Moosie Hawk, Wind Cuffer- Common Kestrel, Falco tinnunculus
Muir-hen- Red Grouse, Lagopus lagopus
Water-hen- Common Moorhen, Gallinula chloropus
Snaith- Common Coot, Fulica atra
Chaldro- Eurasian Oystercatcher, Haematopus ostralegus
Sand Lark- Common Ringed Plover, Charadrius hiaticula
Pliver- Eurasian Golden Plover, Pluvialis apricaria
Teeick- Northern Lapwing, Vanellus vanellus
Horse-Gowk- Common Snipe, Gallinago gallinago
Whaup- Eurasian Curlew, Numenius arquata
Boondie- Common Sandpiper, Actitis hypoleucos
Stoney-Putter- Ruddy Turnstone, Arenaria interpres
Bonxie- Great Skua, Stercorarius skua
Skootie Allan- Arctic Skua, Stercorarius parasiticus

Kittick- Black-legged Kittiwake, Rissa tridactyla
Rittock- Common Black-headed Gull, Larus ridibundus
White-Maa- Common Gull, Larus canus
Baakie- Great Black-backed Gull, Larus marinus
Pickie-terno- Common Tern, Sterna hirundo and Arctic Tern, Sterna paradisaea
Aak, Skout- Common Guillemot, Uria aalge
Coulter-neb- Razorbill, Alca torda
Tyste- Black Guillemot, Cepphus grylle
Tammy-nortrie, Lyre- Atlantic Puffin, Fratercula arctica
Doo- Rock Dove, Columba livia
Cattie-face- Short-eared Owl, Asio flammeus
Ladies-hen- Eurasian Skylark, Alauda arvensis
Witchuck- Collared Sand Martin, Riparia riparia
Jenny Wren- Winter Wren, Troglodytes troglodytes
Willie Wagtail- Pied Wagtail, Motacilla alba
Titlark- Meadow Pipit, Anthus pratensis
T'angSparrow- Rock Pipit, Anthus petrosus

How to Get there

Ferry Service

There are the following Ferry services between the mainland of Scotland and the Orkney Islands:

Northlink Ferries
Runs between Scrabster and Stromness, and carries vehicles as well as passengers.
They also run a car and passenger service between Aberdeen and Kirkwall
http://www.northlinkferries.co.uk/

Pentland Ferries
Runs between Giles Bay and St Margaret's Hope and carries vehicles as well as passengers.
http://www.pentlandferries.co.uk/index.asp

John O' Groats Ferry
John O' Groats Ferry run a passenger only Ferry from John O' Groats to Buwick
http://www.jogferry.co.uk/

By Air
There are flights into Kirkwall airport, many by Loginair and British Airways.
http://www.loganair.co.uk/
http://www.britishairways.com

How to get around the islands of Orkney

Getting between Islands

The following islands are serviced by Orkney Ferries:
From Kirkwall, Mainland: Eday, Egilsay, Flotta, Graemsay, Hoy, North Ronaldsay, Papa Westray, Sanday, Shapinsay, Stronsay and Westray
from Tingwall: Rousay, Egilsay and Wyre

You can find timetables on their website:
http://www.orkneyferries.co.uk/

Loganair flies from Kirkwall airport to:
North Ronaldsay, Papa Westray, Stronsay, Sanday, and Westray.

You can find timetables on their website:
http://www.loganair.co.uk/

Getting around the Mainland

Beside using your own or a rental car, it is reasonable to use a bicycle to reach many of the main birding sites in Orkney and there are rentals available.

Stage coach in Orkney offer the following information on bus use:
"Stagecoach in Orkney operates most of the public bus routes on mainland Orkney. Routes cover St Margaret's Hope, Holm, Kirkwall, Finstown to Stromness, Kirkwall to Birsay, Houton, Deerness, Kirkwall Airport, Hatston Pier, Tingwall Pier, Dounby and Harray. Kirkwall Travel Center is the main bus hub with a waiting area, luggage lockers and an information desk. There is also a travel center in Stromness at the ferry terminal. timetables are displayed at the travel centers, bus stops and on the council website.
More information is available by telephoning Stagecoach in Orkney at 01856 878014. Buses link with ferries to and from other islands and inter-isles flights, as well as ferries and flights to mainland Scotland."

The RSPB Reserves

The Royal Society for the Protection of Birds is the largest single landowner in the Orkney Islands and the property they have on their Preserves is home to some of the most spectacular and interesting birds in the United Kingdom and, indeed, the world. They help to make finding birds in Orkney much easier for the visiting birder. There is no admission charge to any of the Orkney Reserves

Birsay Moors, Mainland

GPS Position: 59° 06'03", -03° 08'49"

Birsay Moors is the author's favorite birding location in Orkney and one of the finest in the world. The banks of peat, wild flowers and heather are home to some of the most sought after birds in the U.K.

Breeding birds:
Greylag Goose, Red Grouse, Red-throated Diver, Western Marsh Harrier, Hen Harrier, Merlin, Eurasian Golden Plover, Northern Lapwing, Dunlin, Common Snipe, Eurasian Curlew, Common Redshank, Great Skua, Parasitic Jaeger/Arctic Skua, Common Black-headed Gull, Lesser Black-backed Gull, European Herring Gull, Great Black-backed Gull, Short-eared Owl. Hooded Crow, Eurasian Skylark, Sedge Warbler, Winter Wren, European Starling, Common Stonechat, Meadow Pipit, Twite and Reed Bunting.

Getting there:
Hillside Road (The B9057) runs between Evie and Dounby, and passes through the reserve. The Burgar Hill hide which overlooks a loch with nesting Red-throated Diver and other excellent species is found by turning west up the sign posted, gravel track from the A966 1 mile (1.6 km) north of Evie.

Brodgar, Mainland

GPS position: 59° 0' 11.68",-3° 13' 47.72"

The Brodgar Reserve is at the heart of Neolithic Orkney. While you look for birds on the Lochs and fields, you can visit the Ring of Brodgar, an impressive circle of standing stones. This area is also excellent in other seasons including the winter when the lochs host waterfowl.

Breeding birds
Gadwall, Common Teal, Mallard, Northern Shoveler, Northern Lapwing, Common Snipe, Eurasian Curlew, Common Sandpiper, Common Redshank, Lesser Black-backed Gull, Eurasian Oystercatcher, Eurasian Skylark, White Wagtail, Meadow Pipit and Common Linnet.

Getting there

The A965 runs between Stromness and Finstown and the B9055 runs north from it to Brodgar about 1.2 miles (2 km.) away. There is a parking lot by the Ring of Brodgar and excellent trails to explore.

Cottascarth and Rendall Moss, Mainland

GPS location; 59° 3' 29.69",-3° 6' 3.79"

Cottascarth and Rendall Moss is a very quiet peaceful place that offers the chance to see some great birds of prey like Hen Harriers, Merlin and Short-eared Owls as well as nesting shorebirds like Common Snipe, Eurasian Curlew and, Common Redshank.

Breeding birds
Mallard, Northern Lapwing, Common Snipe, Eurasian Curlew, Common Redshank, Hen Harrier, Merlin, Short-eared Owl, Hooded Crow, Eurasian Skylark, Sedge Warbler, Winter Wren, Eurasian Blackbird, Meadow Pipit and Twite

Getting there:
Go north from Finstown on A966 for 3 miles (5 km.) and at turn left on Lyde Road and follow it for 1.4 miles (2.2 km) to Lower Cottascarth Farm.

The Loons and Loch of Banks, Mainland

GPS position: 59° 5' 51.17",-3° 19' 1.21"

The Loons and Loch of Banks are the largest wetlands in Orkney and home to many species of waterfowl as Snipe and Curlews. The hide at The Loons is a great way to watch life unfold in the marsh

Breeding birds

Greater White-fronted Goose, Greylag Goose, Eurasian Wigeon, Gadwall, Common Teal, Mallard, Northern Shoveler, Tufted Duck, Red-breasted Merganser, Grey Heron, Little Grebe, Water Rail, Common Moorhen, Common Coot, Northern Lapwing, Common Snipe, Eurasian Curlew, Common Sandpiper, Common Greenshank, Common Redshank, Common Black-headed Gull, Great Black-backed Gull, Meadow Pipit, Common Linnet, Twite, Hooded Crow, Sedge Warbler, Winter Wren, Eurasian Blackbird and Reed Bunting

Getting there
From Birsay take the A967 for 2.6 miles (4.2 km.) and turn right on Loon Road and after 1.5 miles (2.4 km) you will see the hide.
To go from Dounby drive west on A986 and continue on A967 and you will reach Loon Road after 4.8 miles (7.7 km). Turn right on Loon Road and after 1.5 miles (2.4 km) you will see the hide.

Marwick Head, Mainland

GPS Position: 59° 5' 47.57",-3° 20' 49.35"

When it is breeding season, the cliffs of Marwick Head will be filled with birds and the sights, smells and sounds of thousands of seabirds is an experience no one is likely to forget.
As you leave the car park to move up the hill to the sea cliffs, you may see Twite, Stonechat, Skylarks, Lapland Plover, Oystercatcher and Northern Wheatear.
The cliffs themselves host Northern Fulmar, Guillemots, Razorbills, Puffins and Kittiwakes on the lookout for marauding Skua, Great Black-backed Gull and Raven.

You will also see fields of wildflowers surrounding the stone tower memorial to Lord Kitchener who perished with hundreds of sailors when the HMS Hampshire struck a mine near these cliffs.

Breeding birds
Northern Fulmar, Black-legged Kittiwake, Common Gull, European Herring Gull, Great Black-backed Gull, Guillemot, Razorbill, Black Guillemot, Atlantic Puffin, Rock Dove, Eurasian Jackdaw, Common Raven, Swallow, Northern Wheatear, Meadow Pipit and Rock Pipit.

Getting there:
From the town of Birsay go south on A967 for 0.8 miles (1.3 km.) and turn right on B9056 and after 2 miles (3.2 km.) you will find the entrance and car park for the reserve.

From the town of Skaill go north for 4.3 miles (6.9 km.) and you will find the entrance and car park for the reserve.

Hobbister, Mainland

Hobbister offers a wide variety of habitat with moorland and sea cliffs, sand flats and wetland. There is a corresponding wide variety of birds to be found as well.

GPS position: 58° 56' 43.76",-3° 3' 8.089"

Breeding birds:
Mallard, Red-breasted Merganser, Red Grouse, Red-throated Diver, European Shag, Common Snipe, Eurasian Curlew, Common Redshank, Common Black-headed Gull, Lesser Black-backed Gull, European Herring Gull, Great Black-backed Gull, Common Tern, Arctic Tern, Hooded Crow, Eurasian Skylark, Winter Wren, Eurasian Blackbird, Common Stonechat, Meadow Pipit and Twite.

Getting there
From Kirkwall take the A964 and you will see the reserve entrance after 3.1 miles (5km.)

Hoy

The best way to experience the Hoy Reserve is to take the walk to the famous sea stack, the Old Man of Hoy. This 3 mile (4.8 km) hike each way will bring you through the moorland, down through the Valley of the Bonxies (Greater Skua) to the cliffs where you will find sea cliffs that will delight you with the views and the birds. As well as the Old Man of Hoy, you will see St Johns Head, the highest sea cliffs in Britain.

GPS Position: 58° 54' 40.58",-3° 21' 5.67"

Breeding birds
Red-throated Diver, Northern Fulmar, Manx Shearwater, Hen Harrier, Eurasian Buzzard, Peregrine Falcon, Eurasian Golden Plover, Dunlin, Puffin, Great Skua, Kittiwake, Common Tern, Goldcrest, Song Thrush, Common Stonechat and Chaffinch.

Getting there
From the Lyness Ferry turn right onto the B9047 and after 8.1 miles (13 km) take the first left toward Rackwick. On the way to Rackwick you will see a sign for the Dwarfie Stone which is worth a stop. Look also for Red-throated Diver on the small lochs along this road. Park at Rackwick beach for the trail to the Old Man of Hoy.

Sandy Loch is reached by .continuing straight rather than turning to Rackwick on B9047 and after 0.9 miles (1.5 kn), turning left on an unnamed road and driving 0.7 miles (1.1 km).

Mill Dam, Shapinsay

This area was a wetlands which was dammed in the 1880's. It offers wildfowl and waders a breeding habitat and is attractive to birds in other seasons as well.

GPS position: 59° 2' 39.01",-2° 54' 9.91"

Breeding birds:
Eurasian Wigeon, Gadwall, Common Teal, Mallard, Northern Shoveler, Common Pochard, Tufted Duck, Red-legged Partridge, Little Grebe, Water Rail, Common Moorhen, Common Coot, Northern Lapwing, Common Snipe, Eurasian Curlew, Common Black-headed Gull, Sedge Warbler and Eurasian Blackbird.

Getting there:
The Ferry to Shapinsay is at the Kirkwall Harbour on the Great Western Road. In summer there are multiple return trips a day for the 25 minute crossing. You can take autos or bicycles for a charge or you can walk from the Ferry to the reserve, a distance of 0.6 miles (1 km)

Trumland, Rousay

Trumland is Moorland with small lochs and provides an excellent habitat for many bird species as well as wildflowers.

GPS Position: 59° 7' 49.98",-3° 0' 10.33"

Breeding birds:
Northern Fulmar,Red-throated Diver, Hen Harriers, Merlins, Short-eared Owls and Willow Warbler.

Getting there:
The Ferry to Rousay leaves from the Tingwall Harbour in Evie. In summer there are multiple return trips a day for the 30 minute crossing. You can take autos or bicycles for a charge or you can walk from the Ferry to the reserve, a distance of 1 miles (1.6 km).

Onziebust, Egilsay

Wetlands and two open lochs provide sanctuary for some interesting birds. It attracts waterfowl in migration as well.

GPS Position: 59° 9' 20.66",-2° 55' 53.68"

Breeding birds:
Common Teal, Mallard, Northern Shoveler, Tufted Duck, Red-breasted Merganser, Common Eider Water Rail, Common Moorhen, Common Coot, Corncrake, Northern Lapwing, Common Snipe, Eurasian Curlew, Common Redshank, Hooded Crow, Eurasian Skylark, Swallow, Sedge Warbler, Meadow Pipit and Twite.

Getting there:
The Ferry to Egilsay leaves from the Tingwall Harbour in Evie. In summer there are multiple return trips a day for the 50 minute crossing (25 minute return). You can take autos or bicycles for a charge or you can walk from the Ferry to the reserve, a distance of 0.6 miles (1.0 km)

Noup Cliffs, Westray

This is the largest seabird colony in Orkney and the visit will include some stunning landscapes as well as beautiful wildflowers. If you are traveling by road from the Ferry, you may want to stop at the Castle O'Burrian and have a close up view of a Puffin colony.

GPS Position: 59° 19' 52.28",-3° 4' 13.043"

Breeding birds:
Northern Gannet, Common Black-headed Gull, Common Gull, Kittiwake, Great Black-backed Gull, Arctic Tern, Guillemot, Razorbill, Black Guillemot, Atlantic Puffin and Common Raven.

Getting there:
The Ferry to Westray is at the Kirkwall Harbour on the Great Western Road. In summer there are multiple return trips a day for the 1 hour 25 minute crossing. You can take autos or bicycles for a charge.
Loganair also flies to Westray from Kirkwall Airport.

From the Ferry landing it is 7.2 miles (11.5 km) to the reserve on B9066. Signposted. For the Castle O'Burrian, take a left turn and go west on a unnamed road where you see a sign saying "Puffins" which is 1.5 miles (2.4 km) from the Ferry pier.

North Hill, Papa Westray

North Hill doesn't have the high cliffs of Marwick Head or Noup Cliffs but it is an attractive habitat for many birds and a pleasant place for humans. You may find the rare Scottish Primrose among the many wildflowers.
GPS Position: 59° 22' 3.25",-2° 53' 24.76"

Breeding birds:
Eurasian Golden Plover, Northern Lapwing, Dunlin, Common Snipe, Great Skua, Arctic Skua, Kittiwake, Lesser Black-backed Gull, European Herring Gull, Great Black-backed Gull, Arctic Tern, Guillemot, Atlantic Puffin, Common Raven, Eurasian Skylark, European Starling, Northern Wheatear, White Wagtail, Meadow Pipit,
Rock Pipit and Twite.

Getting there:
The Ferry to Papa Westray is at the Kirkwall Harbour on the Great Western Road. In summer there are multiple return trips a day for the 2 hour 15 minute crossing trip (1 hour 50 minute return). You can take autos or bicycles for a charge.
There is also a Ferry from Westray which is passenger only on some days of the week.
Loganair also flies to Papa Westray from Kirkwall Airport.
From the Ferry landing it is 3.2 miles (5.1 km) north on the main road from the Ferry pier.

Copinsay

Copinsay is reserve on an uninhabited island which lies to the east of mainland and which includes three other very small islands, Corn Holm, Ward Holm, Black Holm as well as the Horse of Copinsay.

Part of the island has been set aside to grow hay as a habitat for Corncrakes and there is a large seabird colony. There is no regular Ferry service to the island.

Breeding birds:

Northern Fulmar, European Storm Petrel, European Shag, Corncrake, Eurasian Oystercatcher, Northern Lapwing, Common Snipe, Eurasian Curlew, Common Shelduck, Common Eider, Kittiwake, Common Gull, Guillemot, Razorbill, Atlantic Puffin, Hooded Crow, Eurasian Skylark, Swallow, Eurasian Blackbird, Northern Wheatear, Meadow Pipit, Rock Pipit and Twite.

Getting there;
There is no Ferry service and reaching the reserve is only possible by a private arrangement of transportation.

Other good sites

Birsay, Mainland

The harbour and island by the town of Birsay are excellent for birds and other wildlife.
The bay holds waterfowl in all season and you may see Gray Seals along the shore as well as Otters. The rocky shoreline ledges are good for feeding waders such as Dunlin, Turnstones, and Whimbrel.

The island or Brough of Birsay can be reached by a concrete walk by the car park when the tide is low. If you are going on the island, watch the tides as you may find no dry path to get off as the water rises. You can take the path past the remains of a Pictish settlement to wards the lighthouse near the top of the island. In summer you will see Puffins, Razorbills, and Guillemots as well as many other seabirds.

Skaill, Mainland

The Bay of Skaill attracts a lot of birds. Waterfowl such as Eider with chicks are easy to see in breeding season and waders are common seen on the sandy beach or rock shale.
On the rock ledges on the north side of the bay close views can be had of nesting Fulmars. The grassy crest behind the ledges hold Twite, Meadow and Rock Pipit as well as Northern Wheatear.
A short drive south of the bay is the Loch of Skaill which is a magnet for waterfowl in all seasons.
The Bay of Skaill is beside B9056 just north of the village of Skaill while the Loch of Skaill is further south by this road.

Castle O'Burrian

The Castle O'Burrian on Westray is one of the best places in Orkney for close views of Puffins as well as other species. Look at the Noup Cliff, Westray entry for further information.

North Ronaldsay

In the citations for individual bird species, you will often find reports from North Ronaldsay. Most of these observations are made of migrant birds as North Ronaldsay is renowned for the number of birds, both common and rare, that pass through this area. An observatory was established there in 1987 and they carry out extensive ringing or banding operations.

There are accommodations at North Ronaldsay for visitors who wish to stay there. You can find further information at their website http://www.nrbo.co.uk/.

We stayed there in July, 2011 and the birds were excellent even in summer as was the food and lodging.

North Ronaldsay can be reached by Ferry from Kirkwall or by air from Loganair leaving from Kirkwall airport.

Since there are no sea cliffs, Northern Fulmars raise their chicks on the rocky beach behind the stone dykes.

From the Ferries

Getting to and around the Orkney Islands often involves trips on the ferries. They are golden opportunities for seabird sighting. Get your gear and stake out a good viewpoint as soon as you get on board.

Self Guided Tours

If you have one to three free days on the Mainland in Orkney, the following is a suggestion of a productive way to spend it. If you have only one day you could not do better than splitting the time between Marwick Head and Birsay Moors. If you have a few you might consider the following:

Tour One- Searching for seabirds, Mainland

Warning: Marwick Head is a high open cliff and anyone falling from it will not survive. Conditions can be wet and it often has high gusty winds. Be careful and extra careful if you have children with you.

Marwick Head is at GPS position 59° 5' 47.57",-3° 20' 49.35" and you can reach it as follows:

From the town of Birsay go south on A967 for 0.8 miles (1.3 km.) and turn right on B9056 and after 2 miles (3.2 km.) you will find the entrance and car park for the reserve.

From the town of Skaill go north for 4.3 miles (6.9 km.) and you will find the entrance and car park for the reserve. After leaving your car in the car park head uphill along the fenced trail.

On the way you may see Stonechat, Twite, Blackbird, Starling and Meadow Pipits.

When you reach the top gradually make your way in the direction of the memorial Tower and keep a lookout for Northern Wheatear and Rock Pipit on the grassy area behind the cliff. You are also going to see Northern Fulmar doing effortless glides along the face of the cliff, and a mix of other birds such as Great Skua, Great Black-backed Gull and perhaps a peregrine, all looking for a meal.

Watch for Ravens around Kitcheners Memorial as it seems to be a favoured spot.
As you proceed farther past the tower you will see that the cliff face begins to jut out more towards the see and if you find a viewpoint from this area, you will get a great full view of the face of the cliff and the nesting birds.

In breeding season, this presents a scene that won't be forgotten by a bird enthusiast, rows of ledges with nesting Fulmars, Guillemots, Razorbills, Kittiwakes and perhaps a Jackdaw or Rock Dove. Watch for drama as Skuas and other predators look for unguarded chicks.

We will now head for the town of Birsay and the island just offshore from the town. The Brough of Birsay is a tidal island and can only be reached with dry feet when the tide is low enough. You may want to go there before Marwick Head, so check on the tide tables on the internet or the newspaper.

To reach the town of Birsay drive east for about 0.7 miles (1.1 km) and turn left on B9056. Drive for 2.2 miles (3.5 km) and turn left on A967. After 0.8 miles (1.3 km) turn left on A966 and the town is 0.4 miles (0.6 km). The fields by the roads may often hold Grayleg Geese, Hooded Crows, Snipe, Redshank, Curlews, Rooks and Jackdaws.

At the entrance to the town you will see the ruins of the Earl's Palace, built in the 16th Century, and ,behind it, an interesting mill. Both are worth having a look at.

You can continue along a short rough road to a car park opposite the island.

The rocky shore that borders this road is worth examining. There are often Redshank to be seen or other early migrant waders or gulls.

There is a man made path to the Brock of Birsay and as you take the trail up the hill on it, you will pass an excavation and exhibit of an extensive Norse settlement with traces of Pictish as well.
At the crest of the island is a lighthouse and on the edges at the clifftops, Atlantic Puffin prefer to dig their nesting burrows. You may also expect to see Northern Fulmar, Guillemots, Razorbills and Black Guillemots as well as Kittiwakes and Great Black-backed Gulls.

While there is much to see on the Brock, it is also a beautiful place to spend some time and ideal for a family outing.

Tour two - Marshes and Moors, Mainland

Our tour starts at the Loch of Banks and The Loons.
From Birsay take the A967 for 2.6 miles (4.2 km.) and turn right on Loon Road and after 1.5 miles (2.4 km) you will see the hide at The Loons. The GPS Position is 59° 5' 51.17",-3° 19' 1.21".

The hide is a great place to spend some time looking for birds of the wetlands. From the hide you might see Eurasian Wigeon, Gadwall, Common Teal, Mallard, Northern Shoveler, Tufted Duck, Red-breasted Merganser, Grey Heron, Common Moorhen and Common Coot. Little Grebe and Water Rail are less common but possible. Waders are represented by Northern Lapwing, Common Snipe, Eurasian Curlew, Common Sandpiper, Common Greenshank and Common Redshank. Overhead you may see Black-headed Gull, Great and Lesser Black-backed Gull, Herring Gull, Hooded crow, the occasional Skua or raiding Peregrine. In the reeds look for Sedge Warbler and Reed Bunting.

You can stop at other convenient lay-byes on the roads around the marsh for additional views.

Our next stop is the Birsay Moors and to get there we need to drive to Dounby. The Birsay Moors are at GPS Position 59° 06'03", -03° 08'49"

Head back on Loon Road and turn right on A967 and continue on A966. Drive 3 miles (4.8 km) and turn left on Hillside Road. If you want a great lunch before heading to the Birsay Moors, stop at the Smithfield Hotel at the corner, it is highly recommended.
The Hillside Road from Dounby to Evie is 5.7 miles (9.1 km) long and passes through the heat of the Birsay Moors Reserve.
You will come to a small water crossing just before reaching the moorland and if you look in mid to late summer, you are likely to see a number of Lesser Black-backed Gulls, both adults and juveniles, loafing about the water.

As you drive farther up the road into the reserve itself, you will find a number of convenient lay-byes where you can stop and observe, or park and walk. From the first or second stop, you can walk downhill into a valley favoured by nesting Arctic Skua and Great Skua. They may make themselves known by harassing you with close fly-byes. Don't go too close to nesting birds and disturb them. This is also a great spot to see hunting Hen Harriers quartering the fields.

Going uphill from the road brings you to banks where peat has been cut and among the many interesting plants and wildflowers, you might encounter a Short-eared Owl, Merlin, Red Grouse or Stonechat. Nesting waders may include Golden Plover and lapwing, Dunlin, Snipe, Curlew and Redshank.

There is a car park towards the Evie side of the Reserve which provides a good base for exploring and you could find Hooded Crow, Skylark, Sedge Warbler, Winter Wren, European Starling, Meadow Pipit and Twite.

Our final stop is the hide at Burgar Hill. Continue to the end of the road at Evie and turn left on A966. After 1 mile (1.6 km) turn left on a sign posted, gravel track and take this winding road up toward the large wind turbines. When you reach the top go left and you will find the hide.

From the hide you can look over Lowrie's Water, home to nesting Red-throated Diver. This is a marvelous place to watch an Orkney specialty as it displays and cares for its young. Eurasian Wigeon also breed here and Greylag Geese have become common in the last few years. You may also see waders and a passing Harrier or other hunting raptor.

Tour Three- Wonderful Westray

The Ferry to Westray can be caught at Kirkwall Harbour on the Mainland and you can take your auto on it. The crossing takes one hour and 25 minutes and you will see a wealth of birds from the deck.

Look for Cormorants, Eiders, Guillemot, Razorbill, Black Guillemot, Atlantic Puffin and a host of gulls on the water or overhead.

After you disembark the Noup Cliff Reserve is 7.2 miles (11.5 km)on B9066. However we are going to make a stop at the Castle O'Burrian first. We need to take a left turn and go west on a unnamed road where you see a sign saying "Puffins" which is 1.5 miles (2.4 km) from the Ferry pier.

The Castle O'Burrian has a very accessible Puffin colony where you can view and photograph the birds from close quarters. You can also find good spots where birds will be flying in and away. This will include Guillemots, Razorbills, Black Guillemots and Atlantic Puffins.

Before you continue to the Noup Cliff Reserve you can make a side trip to the ruins of Noltland castle which was built in the 16th century and found at GPS Position 59° 19' 14.52", -3° 0' 15.84". You will turn left from Pierowall off BB9066 on an unnamed road which is 6.9 miles (11 kms) from the Ferry pier.

As you enter the Noup Cliff Reserve you may be greeted by the sight of hundreds of Arctic terns nesting but there have been years when very few pairs can be seen. In 2011 the various colonies suffered almost complete breeding failure This may be due to prey stocks but it is not known for sure.

One species that is increasing in breeding numbers is the Northern Gannet. You can also expect to see Common Black-headed Gull, Common Gull, Kittiwake, Great Black-backed Gull, Guillemot, Razorbill, Black Guillemot, Atlantic Puffin and Common Raven.

The winds can be very strong so be very careful near the edge of the cliffs. Sometimes this creates a good opportunity for photographers as auks may have difficulty returning to the breeding ledge and will often hang motionless while they attempt to navigate in and these can give some wonderful flight images.

Bird List
Anatidae, Ducks, Geese and Swans

Mute Swan, *Cygnus olor*
Uncommon breeder and common otherwise
Breeding pairs may be found throughout the Islands with larger numbers of the Mainland Lochs of Harray, Stenness and Bosquoy. Can be found in many Lochs in other seasons.

Bewick's/Tundra Swan, *Cygnus columbianus*
Accidental
About 20 records with the last in 2012

Whooper Swan, *Cygnus cygnus*
Common passage migrant and winter visitor, occasional summer records.
Passage migrants peak in mid-March and mid-October. It is widespread in small numbers in winter. Occasional summer sightings are usually single birds.

Bean Goose, *Anser fabalis*
Irregular winter visitor
n some years birds of this species are not seen although they seem to be more regular in the last few years. Both *A.f. Rossicus* and *A. f. Fabalis* I may be seen.

Pink-footed Goose, *Anser brachyrhynchus*
Common Passage migrant and winter visitor
This species has become more common and regular in winter.

Greater White-fronted Goose, *Anser albifrons*
Uncommon passage migrant and winter visitor
This species has declined as a winter visitor and is best found at this time of year at The Loons. Most visitors are the Greenland White-fronted Goose (*A. a. flavirostris*). The European White-fronted Goose (*A.a. albifrons*) is a rare visitor, usually in North Ronaldsay.

Greylag Goose, *Anser anser*
Abundant passage migrant, common breeder and winter resident
This species used to be a rare breeder but has become common in the last few decades. Found breeding on Birsay Moors, The Loons as well as many lochs on the mainland and other islands. In winter, they can usually be found in numbers on the Loch of Harray.

Snow Goose, *Anser caerulescens*
Rare, has bred
Although seen in very low numbers, it has increased recently, likely due to birds of feral origin. It first bred in 2009 and repeated in 2010 and 2011 (two records).

Canada Goose, *Branta canadensis*
Rare
Seen annually in winter, often in good sized flock numbers

Barnacle Goose, *Branta leucopsis*
Common Passage migrant and winter visitor
There is a winter population on the island of South Walls and birds which may be from there and others are found on Lochs throughout the Islands in winter. Flocks in the hundreds may be seen in migration.

Brent/Brant Goose, *Branta bernicla*
Rare passage migrant
This species was apparently much more common as a migrant many years ago but is rare now. Birds of the Pale-bellied Brent Goose (*B. b. hrota*) and Dark-bellied Brent Goose (*B. b. bernicla*) may be seen.

Egyptian Goose, *Alopochen aegyptiaca*
Accidental
One record of this introduced species in 2008

Ruddy Shelduck, *Tadorna ferruginea*
Accidental
Only a handful of records with the last in 2005

Common Shelduck, *Tadorna tadorna*
Common Breeder
Breeds widely in small numbers. Look for it in Birsay, the Loch of Skaill, Harray, Orphir, Stromness and on many of the other Islands. Most birds have migrated by August and return near the end of the year.

Mandarin Duck, *Aix galericulata*
Introduced species
About 10 records of this species which escapes from collections. The last was in 2010. The author had the unusual sighting from the Ferry of one in the open sea off of Hoy

Eurasian Wigeon, *Anas penelope*
Uncommon breeder, abundant migrant and winter visitor
Breeds in small numbers in widespread locations including The Loons and Mill Dam in Shapinsay. During winter and migration, large flocks can often be found, favoured areas are the Loch of Harray, the Mill Dam and Widewall Bay in South Ronaldsay.

American Wigeon, *Anas americana*
Rare/Accidental
Accidental with the last records in 2012

Gadwall, *Anas strepera*
Uncommon breeder, passage migrant and winter visitor
Looks for small numbers of breeding birds on Loch of Banks, Brodgar, The Loons and Mill Dam in Shapinsay as well as other small Lochs. Winter birds are mainly found on the Loch of Stenness with smaller numbers elsewhere.

Common Teal, *Anas crecca*
Common breeder, migrant and winter visitor
On RSPB Reserves Loch of Banks, Birsay, Brodgar, The Loons, Mill Dam and Onziebust as well as a small number of other localities. Widespread in varied numbers in winter.

Green-winged Teal, *Anas carolinensis*
Rare/Accidental
Thirty-seven records with the last in 2012

Mallard, *Anas platyrhynchos*
Common breeder found in all seasons
Found in the Reserves of Brodgar, Cottascarth, The Loons, Hobbister, Loch of Banks, Mill Dam, and Onziebust, as well as many other localities. Widespread in winter, look on the Loch of Skaill, the Peerie Sea and Birsay.

Northern Pintail, *Anas acuta*
Uncommon breeder, migrant and winter visitor
Usually only a small number of breeding pairs are seen with varied numbers seen in other seasons.

Garganey, *Anas querquedula*
Rare in summer and migration, very rare breeder
Seen annually favouring North Ronaldsay and a few breeding records.

Blue-winged Teal, *Anas discors*
Rare/Accidental
Less than a dozen records, the last in 2009.

Northern Shoveler, *Anas clypeata*
Common breeder and passage migrant, uncommon in winter
Breeds on the RSPB Reserves of Brodgar, Loch of Banks, The Loons, Mill Dam and Onziebust in addition to widespread other suitable areas. Small numbers winter in the same locations.

Red-crested Pochard, *Netta rufina*
Introduced species
Five accepted sightings with the last in 2003.

Canvasback, *Aythya valisineria*
Rare/Accidental
One sighting in 2000

Common Pochard, *Aythya ferina*
Occasional breeder, common in winter
Recent breeding at Mill Dam in Shapinsay. The Loch of Harray is favoured by winter birds.

Ring-necked Duck, *Aythya collaris*
Rare/Accidental
Five records with the last in 2011

Ferruginous Duck, *Aythya nyroca*
Rare/Accidental
One record from 1981

Tufted Duck, *Aythya fuligula*
Common breeder and winter visitor
Breeds in the RSPB Reserves Loch of Banks, The Loons, Onziebust and Mill Dam and other suitable sites on the islands. In winter look for it on the Lochs of Stenness and Harray.

Greater Scaup, *Aythya marila*
Common winter visitor , has bred
Main winter areas are the Lochs of Stenness and Harray.

Lesser Scaup, *Aythya affinis*
Rare/Accidental
Four records with the last in the winter 2011-12

Common Eider, *Somateria mollissima*
Common resident and breeder
Widespread om coastal shores. Look for at Birsay and the Bay of Skaill.

King Eider, *Somateria spectabilis*
Rare/Accidental
Two dozen records with the last in 2010

Steller's Eider, *Polysticta stelleri*
Rare/Accidental
Four records with none since 1976

Long-tailed Duck, *Clangula hyemalis*
Occasional summer, has bred, common in winter
Large concentrations may be found in winter in the open sounds and larger lochs, particularly Harray and Stenness.

Common Scoter, *Melanitta nigra*
Uncommon visitor, has bred
This species shows up at varied locations, usually juveniles and females. Keep a lookout between islands from the ferries and rarely from the larger Lochs

Surf Scoter, *Melanitta perspicillata*
Rare/Accidental
Over 2 dozen records, the last in 2012

Velvet Scoter, *Melanitta fusca*
Uncommon to common in winter
Found in winter in the sounds between islands. A favoured spot is Deer Sound, about 1 mile (1.6 km) east of the Kirkwall Airport

Common Goldeneye, *Bucephala clangula*
Common winter visitor, occasional in summer
The Lochs of Stenness, Harray and Skaill are favoured by winter visitors.

Smew, *Mergellus albellus*
Rare
Seen in most years with 2012 being no exception. Loch of Skaill is a favoured site.

Red-breasted Merganser, *Mergus serrator*
Fairly common breeding species, common in winter
Bred at RSPB Reserves The Loons, Hobbister, and Onziebust as well as Lochs of Stenness and others. Widespread in winter.

Goosander/Common Merganser, *Mergus merganser*
Rare
Small numbers seen annually on widespread Lochs

Ruddy Duck, *Oxyura jamaicensis*
Occasional
Many records but none since 2009

Phasianidae, Grouse and Partridge

Willow Grouse/Red Grouse, *Lagopus lagopus*
Fairly common breeding resident
Found in various areas in the right habitat. Some of the best places to look are the Birsay Moors and the Hobbister Reserve

Rock Ptarmigan, *Lagopus muta*
Extinct
Used to breed in Hoy but has been extinct since about 1831.

Eurasian Black Grouse, *Lyrurus tetrix*
Introduced species, Extinct
An introduction of this species was made about 1859 which failed and the species is extinct in Orkney

Red-legged Partridge, *Alectoris rufa*
Introduced species, small numbers breed
Has been introduced on Shapinsay for hunting. Best spot to see them is probably near Mill Dam where they have bred.

Grey Partridge, *Perdix perdix*
Introduced species, Extinct
There have been several introductions of this species which have failed.
A pair of birds from a 1970's release in Shapinsay successfully bred but the species has failed to establish itself.

Common Quail, *Coturnix coturnix*
Rare visitor in summer and migration and rare breeder
It rarely is found on the islands with a slight preference for North Ronaldsay, Westray and Papa Westray.

Common Pheasant, *Phasianus colchicus*
fairly Common breeder, introduced
Found throughout the mainland

Gaviidae, Divers (Loons)

Red-throated Diver/ Loon, *Gavia stellata*
Fairly common breeder, uncommon in winter
Found at RSPB Reserves at Birsay Moore (easily at Burgar Hill hide), Hobbister and North Hoy as well as other sites throughout the Islands.

Black-throated Diver/Arctic Loon, *Gavia arctica*
Uncommon winter visitor
Regular but uncommon on areas like Scapa Flow in winter

Great Northern Diver /Common Loon, *Gavia immer*
Common Winter visitor, uncommon in summer
Widespread in winter with Scapa Flow a favoured spot. Found in summer in various localities including North Ronaldsay.

White-billed Diver/Yellow-billed Loon, *Gavia adamsii*
Rare/Accidental
It has been found annually since 2005 with a preference for the month of April.

Diomedeidae, Albatross

Black-browed Albatross, *Thalassarche melanophrys*
Rare/Accidental
Two records, one in 1969 and in 1975.

Procellariidae, Petrels and Shearwaters

Northern Fulmar, *Fulmarus glacialis*
Abundant breeder and migrant
The Fulmar was uncommon in the 19th century and the first breeding record was not until one on Hoy in 1900. From that point it spread throughout the islands until its present abundance. The author has seen birds nesting in old quarries away from the

sea and on North Ronaldsay, they nest almost at sea level against the stone sheep dyke.

The Bay of Skaill presents easy spots to view and photograph nesting birds, as does Marwick Head.

Cape Verde/Zino's/Fea's Petrel, *Pterodroma feae*
Rare/Accidental
Two records with the last in 2010

Cory's Shearwater, *Calonectris diomedea*
Rare/Accidental
20 Records with the last in 2009

Great Shearwater, *Puffinus gravis*
Rare
It has been noted almost annually in very small numbers in the last few years. Most records have occurred off North Ronaldsay

Sooty Shearwater, *Puffinus griseus*
Common autumn migrant
Can be seen at sea as early as July. Watch from the ferries especially in the Northern islands

Manx Shearwater, *Puffinus puffinus*
Uncommon breeder, common migrant
There is a breeding colony on Hoy. Probably easiest to see during migration with North Ronaldsay being a good location.

Balearic Shearwater, *Puffinus mauretanicus*
Rare
Less than 20 records with the last on in 2011 off North Ronaldsay.

Hydrobatidae, Storm-Petrels

European Storm Petrel, *Hydrobates pelagicus*
Common breeder and migrant
Although it is fairly common it is not easy to observe. The North Ronaldsay Observatory has banded them nocturnally and attracted good numbers. There is a known breeding site off Copinsay on Corn Holm.

Leach's Storm Petrel, *Oceanodroma leucorhoa*
Uncommon summer visitor and migrant
While trapping European Storm-Petrel on North Ronaldsay, two birds of this species were also trapped and banded. There were also a couple of additional sight records.

Sulidae, Gannets

Northern Gannet, *Morus bassanus*
Common breeder, passage migrant and winter visitor
There are three active breeding colonies in Orkney; Sule Stack, Sule Skerry and Noup Head in Westray. They are widespread and seen at sea in all seasons.

Phalacrocoracidae, Cormorants

Great Cormorant, *Phalacrocorax carbo*
Common breeding and resident
There are active colonies throughout the islands. A good locality in all seasons is the Loch of Harray

European Shag, *Phalacrocorax aristotelis*
Common breeding and resident
There are a number of colonies throughout the islands including the cliffs at Hobbister reserve. They can be seen in all season at places like Stromness harbour.

Ardeidae, Heron and Egrets

Eurasian Bittern, *Botaurus stellaris*
Rare/Accidental
Seven records with the last in 2010

Little Bittern, *Ixobrychus minutus*
Rare/Accidental
Three records with the last in 1971

Black-crowned Night Heron, *Nycticorax nycticorax*
Rare/Accidental
Six records with the last in 1998

Squacco Heron, *Ardeola ralloides*
Rare/Accidental
One record in 1896

Little Egret, *Egretta garzetta*
Rare/Accidental
Less than 20 records with the last in 2012

Great Egret, *Ardea alba*
Rare/Accidental
Five records with the last in 2009

Grey Heron, *Ardea cinerea*
Common passage migrant and winter visitor, has bred
Widespread throughout the islands and found in all seasons. The Loons is a prime locality

Purple Heron, *Ardea purpurea*
Rare/Accidental
Two records with the last in 1982.

Great Blue Heron, *Ardea herodias*
Rare/Accidental
A sighting of a 1st winter bird at Bay of Kirkwall Jan. 6-March 31st, 2012 would be a first record if accepted.

Ciconiidae, Storks

Black Stork, *Ciconia nigra*
Rare/Accidental
Five records with the last in 2008

European White Stork, *Ciconia ciconia*
Rare/Accidental
Eight records with the last in 2008

Threskiornithidae, Ibis and Spoonbills

Glossy Ibis, *Plegadis falcinellus*
Rare/Accidental
Five records with the last in 2000

Eurasian Spoonbill, *Platalea leucorodia*
Rare/Accidental
Nine records with the last in 1998

Podicipedidae, Grebes

Little Grebe, *Tachybaptus ruficollis*
Uncommon breeder and winter visitor
Close to a dozen breeding records in 2012 including Loch of Bosquoy, The Loons, Birsay, Loch of Isbister, Loch of Burness, Loch of Banks and Mill Dam. Winter records are widespread in small numbers.

Great Crested Grebe, *Podiceps cristatus*
Rare
Recorded annually in small numbers usually as a passage migrant in varied locations.

Red-necked Grebe, *Podiceps grisegena*
Rare winter records
Annual in small numbers in winter often in Scapa Flow.

Slavonian or Horned Grebe, *Podiceps auritus*
Common winter visitor, occasional in summer
Rafts of this species favour Scapa Flow in winter. A couple of birds in breeding plumage have been seen in summer although there is no evidence of breeding.

Black-necked or Eared Grebe, *Podiceps nigricollis*
Accidental
Three records with the last in 1997.

Accipitridae, Hawks, Eagles and Osprey

European Honey Buzzard, *Pernis apivorus*
Rare
Usually seen annually, last records in 2011

Black Kite, *Milvus migrans*
Rare/Accidental
Up to 2011 there were seven records but three occurred in 2011

Red Kite, *Milvus milvus*
Rare/Accidental
Over a dozen records with the last in 2011

White-tailed Sea Eagle, *Haliaeetus albicilla*
Rare/Accidental, has bred
Multiple records with the last in 2012. The species used to bred here in the 19th Century, primarily in Hoy.

Western Marsh Harrier, *Circus aeruginosus*
Rare to uncommon, has bred
There has been recent breeding activity by this species and perhaps a dozen birds may be present during the season. Sightings are widespread and include the Birsay Moor.

Hen Harrier/Northern Harrier, *Circus cyaneus*
Uncommon breeder and resident
Birds are sighted in widespread area with Birsay Moors being a prime area. Some authorities have split the North American Northern Harrier from the Hen Harrier

Pallid Harrier, *Circus macrourus*
Rare/Accidental
Two records with the last in 2011. There is a record of this species breeding with a Hen Harrier

Montagu's Harrier, *Circus pygargus*
Accidental
One record in 1996

Northern Goshawk, *Accipiter gentilis*
Rare
Seen almost annually with the last record in 2012

Eurasian Sparrowhawk, *Accipiter nisus*
Uncommon breeding species and migrant
Small numbers nest in widespread localities. Migrants may be seen widely as well.

Eurasian Buzzard, *Buteo buteo*
Rare breeder, uncommon migrant and winter visitor
Less than a dozen breeding sites a year are mainly in Hoy, the Mainland and Rousay. During migration sightings are widespread but not numerous.

Rough-legged Buzzard, *Buteo lagopus*
Rare
Almost annual in small numbers in late fall and winter

Golden Eagle, *Aquila chrysaetos*
Rare/Accidental
Two dozen records with the last in 2012

Osprey, *Pandion haliaetus*
Rare
Normally seen as a passage migrant especially in spring

Falconidae, Falcons

Lesser Kestrel, *Falco naumanni*
Rare/Accidental
A single record in 2011 of a bird found on North Ronaldsay.

Common Kestrel, *Falco tinnunculus*
Uncommon breeding species and migrant
The West Mainland seems to be its strongest concentration but birds may be seen in widespread areas. The author has had good luck near the cliffs by the Bay of Skaill.

Red-footed Falcon, *Falco vespertinus*
Rare/Accidental
Sixteen records with the last in 2006

Merlin, *Falco columbarius*
Uncommon breeder, migrant and winter visitor
Breeding has been in decline on the islands. The birds are widespread in all seasons, and as they tend to be visible, can often be seen.

Eurasian Hobby, *Falco subbuteo*
Rare
Recorded almost annually with the last record in 2012

Gyrfalcon, *Falco rusticolus*
Rare/Accidental
Over two dozen records with the last in 2011.

Peregrine Falcon, *Falco peregrinus*
Uncommon resident breeder
The species is found and breeds on most of the larger islands but the cliffs of Hoy are its stronghold.

Rallidae, Rails and Coots

Water Rail, *Rallus aquaticus*
Rare breeder, uncommon migrant and winter visitor
Favoured breeding sites include The Loons, Loch of Banks, Mill Dam and Onziebust. Outside of summer they may be recorded at varied wetland sites.

Spotted Crake, *Porzana porzana*
Rare
Over two dozen records with the last in 2011

Corncrake, *Crex crex*
Uncommon breeder and migrant
The RSPB tries to document calling Corncrakes with public help and there tends to be about two dozen or more over various sites. The author has heard a calling male only once, in a field across from the hide at the Loons.

Common Moorhen, *Gallinula chloropus*
Common breeder, migrant and winter visitor
You may see it this species at the RSPB Reserves of The Loons, Birsay, Loch of Banks, Onziebust, and Mill Dam as well as other wetlands.

Common Coot, *Fulica atra*
Fairly common breeder and winter visitor
You may see it this species at the RSPB Reserves of The Loons, Loch of Banks, Onziebust, and Mill Dam and other wetland locations.

Otididae, Bustards

Little Bustard, *Tetrax tetrax*
Rare/Accidental
One record from 2009

Great Bustard, *Otis tarda*
Rare/Accidental
One record from 1989

Gruidae, Cranes

Common Crane, *Grus grus*
Rare/Accidental
Forty-eight records with the last in 2012

Sandhill Crane, *Grus canadensis*
Rare/Accidental
One record in 2009

Haematopodidae, Oystercatcher

Eurasian Oystercatcher, *Haematopus ostralegus*
Abundant breeder, common in winter
Breeding pairs will be found on most of the RSPB Reserves as well as other suitable habitat

Recurvirostridae, Stilts and Avocets

Black-winged Stilt, *Himantopus himantopus*
Rare/Accidental
One old record from 1814

Pied Avocet, *Recurvirostra avosetta*
Rare/Accidental
Thirteen records with the last in 2009

Burhinidae, Stone-Curlew

Eurasian Stone Curlew, *Burhinus oedicnemus*
Rare/Accidental
Two records with the last in 2010

Glareolidae, Pratincole

Collared Pratincole, *Glareola pratincola*
Rare/Accidental
Two records with the last in 2003

Charadriidae, Plovers

Little Ringed Plover, *Charadrius dubius*
Rare/Accidental
Seven records with the last in 2012

Common Ringed Plover, *Charadrius hiaticula*
Common breeder, migrant and winter visitor
Birds breed on the coastal areas of many areas. Birsay Bay and the Bay of Skaill are good locations

Greater Sand Plover, *Charadrius leschenaultii*
Rare/Accidental
One record in 1979

Eurasian Dotterel, *Charadrius morinellus*
Rare migrant, has bred
Close to 100 records with last in 2012. North Ronaldsay is a favoured location.

American Golden Plover, *Pluvialis dominica*
Rare/Accidental
Thirty-five records with the last in 2012 with six occurrences.

Pacific Golden Plover, *Pluvialis fulva*
Rare/Accidental
Nine records with the last in 2011

Eurasian Golden Plover, *Pluvialis apricaria*
Uncommon breeder, common migrant and winter visitor
Found in the moorland RSPB reserves of Birsay, Hoy and North Hill. North Ronaldsay is a good location for migrants and winter visitors

Grey Plover/Black-bellied Plover, *Pluvialis squatarola*
Uncommon passage migrant and winter visitor
North Ronaldsay is a favoured location for records of migrating birds.

Sociable Plover, *Vanellus gregarius*
Rare/Accidental
Three records with the last in 1969.

Northern Lapwing, Vanellus vanellus
Common breeder, migrant and winter visitor
Easy to find at the RSPB Reserves of Loch of Banks, The Loons, Brodgar, Cottascarth and Rendall Moss, Birsay Moors, Onziebust, North Hill and Mill Dam.

Scolopacidae, Sandpipers

Red Knot, *Calidris canutus*
Fairly common migrant and winter visitor
North Ronaldsay looks like the most favoured destination in migration and the shores at Birsay are worth a look.

Sanderling, *Calidris alba*
Fairly common passage migrant and winter visitor
North Ronaldsay is good for migrants as well as a few winter visitors. Also look at Waukmill Bay and the Bay of Skaill.

Semipalmated Sandpiper, *Calidris pusilla*
Rare/Accidental
Three records with the last in 2002

Western Sandpiper, *Calidris mauri*
Rare/Accidental
One record in 1998

Little Stint, *Calidris minuta*
Uncommon passage migrant
The few records of this species in migration tend to favour North Ronaldsay and Papa Westray

Temminck's Stint, *Calidris temminckii*
Rare/Accidental
Seventeen records with three in 2012

White-rumped Sandpiper, Calidris fuscicollis
Rare/Accidental
Twenty records with the last in 2007.

Baird's Sandpiper, *Calidris bairdii*
Rare/Accidental
Two records with the last in 2012

Pectoral Sandpiper, *Calidris melanotos*
Rare
It normally shows up as a fall passage migrant in widespread localities in very small numbers.

Sharp-tailed Sandpiper, *Calidris acuminata*
Accidental
A sighting July 20, 2012 at Loch of Swartmill would be the first Orkney record if accepted.

Curlew Sandpiper, *Calidris ferruginea*
Uncommon passage migrant
Appears as a passage migrant primarily in Autumn in widespread localities including The Loons, North Ronaldsay and Mill Dam.

Purple Sandpiper *Calidris maritima*
Common migrant and winter visitor
Favoured migrant locations are North Ronaldsay and Newark Bay in Deerness although they are to be looked for on any rocky shores

Dunlin, *Calidris alpina*
Common breeder, migrant and winter visitor
Look for breeding birds on the RSPB Reserves of Birsay Moors, North Hill and Hoy. Migrants may be found at Mill Sand in Tankerness.

Broad-billed Sandpiper, *Limicola falcinellus*
Rare/Accidental
Two records with the last in 1999

Buff-breasted Sandpiper, *Tryngites subruficollis*
Rare
Thirty records with the last in 2012. North Ronaldsay is favoured.

Ruff, *Philomachus pugnax*
Uncommon passage migrant, rare in winter
Migrants seem more common in fall with widespread localities including Marwick Bay and the Tankerness area.

Jack Snipe, *Lymnocryptes minimus*
Uncommon migrant and winter visitor
North Ronaldsay is a favoured location in migration.

Common Snipe, *Gallinago gallinago*
Common breeder, migrant and winter visitor
Look for in the RSPB Reserves of Loch of Banks, Birsay Moor, Brodgar, Cottascarth and Rendall Marsh, The Loons, Hobbister, Mill Dam, North Hill and Onziebust

Great Snipe, *Gallinago media*
Rare/Accidental
Almost two dozen records with the last in 2000

Long-billed Dowitcher, *Limnodromus scolopaceus*
Rare/Accidental
Six records with the last in 2004

Eurasian Woodcock, *Scolopax rusticola*
Fairly common migrant and winter visitor, has bred
Mainly an autumn migrant with North Ronaldsay good for records. There are a few old breeding records.

Black-tailed Godwit, *Limosa limosa*
Rare breeder, common passage migrant
North Ronaldsay, Birsay Bay and Waukmill Bay at Hobbister are possible sites for this species in migration

Bar-tailed Godwit, *Limosa lapponica*
Common in migration and winter
Tankerness and St. Peter's Pool are good sites in all but the summer months

Eurasian Curlew, *Numenius arquata*
Common breeder and abundant in winter
The RSPB Reserves of Loch of Banks, Brodgar, Cottascarth and Rendall Moss, Hobbister, The Loons, Mill Dam, Birsay Moors and Onziebust are good sites and you often find birds in farm fields.

Whimbrel, *Numenius phaeopus*
Rare breeder, fairly common in passage
North Ronaldsay is good for this species during migration. The rocky shore at Birsay can also be good.

Terek Sandpiper, *Xenus cinereus*
Accidental
One record from 1987

Common Sandpiper, *Actitis hypoleucos*
Uncommon breeder and passage migrant
Possible breeding sites include Birsay, Brodgar and The Loons. North Ronaldsay is good for migrants.

Spotted Sandpiper, *Actitis macularius*
Rare/Accidental
Two records with the last in 2008.

Green Sandpiper, *Tringa ochropus*
Uncommon passage migrant
The majority of sightings are from North Ronaldsay for this migrant.

Spotted Redshank, *Tringa erythropus*
Rare in migration
They are found at widespread sites in very small numbers mostly in fall migration.

Common Greenshank, *Tringa nebularia*
Uncommon migrant, has bred
The Loons, Waukmill Bay and North Ronaldsay may be good spots to spot migrants.

Lesser Yellowlegs, *Tringa flavipes*
Rare/Accidental
Five records with the last in 2012

Marsh Sandpiper, *Tringa stagnatilis*
Accidental
One record in 1979

Wood Sandpiper, *Tringa glareola*
Rare passage migrant
Most migrant sightings are from North Ronaldsay

Ruddy Turnstone, *Arenaria interpres*
Uncommon in summer, common migrant and winter visitor
Likely to be found on any rocky shore in migration but look in particular at Birsay, Bay of Skaill and North Ronaldsay.

Common Redshank, *Tringa totanus*
Common breeder, migrant and winter visitor
The RSPB Reserves of Loch of Banks, Brodgar, Cottascarth and Rendall Moss, Hobbister, The Loons, Birsay Moors and Onziebust are good sites in breeding season

Wilson's Phalarope, *Phalaropus tricolor*
Rare/Accidental
Two records with the last in 2002

Red-necked Phalarope, *Phalaropus lobatus*
Has bred, rare visitor
There are about a half dozen breeding records, most from Sanday. Migrants show up in widespread locations in very small numbers

Grey Phalarope/Red Phalarope, *Phalaropus fulicarius*
Rare passage Migrant
Annual in small numbers with the last record in 2012.

Stercorariidae, Skuas and Jaegers

Great Skua, *Stercorarius skua*
Common breeder and passage migrant
Significant numbers of breeding birds can be found at the Hoy Reserve (Valley of the Bonxies). Many birds of this species will be seen if you take the walk to the sea stack called the Old Man of Hoy. There are other colonies of Great Skua are also found on Hoy. If you are on Hoy near late July, make a visit to Sandy Loch, and you may see 40-50 birds, an amazing sight. Birsay Moor, and North Hill also have colonies.

Pomarine Skua, *Stercorarius pomarinus*
Uncommon passage migrant
Most migrant sightings are from the autumn with sighting from widespread localities but especially from North Ronaldsay and Papa Westray.

Arctic Skua/Parasitic Jaeger, *Stercorarius parasiticus*
Common breeder and passage migrant
The Birsay Moor has been prime breeding site for this species but the number of breeding pairs has declined as they have throughout the islands. The North Hill Reserve on Papa Westray has also been important and there are other historic colonies throughout Orkney.

Long-tailed Skua/Jaeger, *Stercorarius longicaudus*
Uncommon passage migrant
Very small numbers seen from varied localities

Laridae, Gulls and Terns

Ivory Gull, *Pagophila eburnea*
Rare/Accidental
Fourteen records but none since 1949

Sabine's Gull, *Xema sabini*
Rare migrant
Most records are from autumn migration of very small numbers in varied locations.

Black-legged Kittiwake, *Rissa tridactyla*
Abundant summer breeder and migrant, uncommon winter visitor
There are about a dozen breeding colonies in Orkney with Marwick Head being very accessible. There have been very large declines of this species in the last few years.

Bonaparte's Gull, *Larus philadelphia*
Accidental
A bird at Graemshall, Holm on Oct 6^{th}, 2011 is the first record for Orkney

Common Black-headed Gull, *Larus ridibundus*
Common breeder, migrant and winter visitor
Look for breeding birds at Noup Cliff, Mill Dam, Birsay Moors, The Loons, Hobbister and Loch of Bank. Birds are common and widespread in all seasons.

Little Gull, *Larus minutus*
Uncommon visitor
Most records are during migration from widespread localities of small numbers

Ross's Gull, *Rhodostethia rosea*
Rare/Accidental
Four records with the last in 2005

Laughing Gull, *Larus atricilla*
Rare/Accidental
Two records with the last in 2005

Mediterranean Gull, *Larus melanocephalus*
Rare
Thirty records from all seasons with the last in 2012

Common/Mew Gull, *Larus canus*
Common breeder, abundant in migration
There have been declines in breeding in recent years but nesting birds can be easily seen in places like Marwick Head, Birsay, Noup Head, North Cliff and many others. Outside of breeding season this species is widespread in large numbers and easy to find.

Ring-billed Gull, *Larus delawarensis*
Rare/Accidental
Twelve records with the last in 2008

Lesser Black-backed Gull, *Larus fuscus*
Common breeder, rare in other seasons
Look for breeding birds in Birsay Moor, Hobbister, Brodgar and North Hill. For an easy view in July and early August take Hillside Road northeast from Dounby and after the road swings east, look for a small burn or creek on the right side. Adults and juvenile birds frequent this area on a very consistent basis.

European Herring Gull, *Larus argentatus*
Common breeding resident
Breeding birds can be looked for at North Hill, Birsay Moors, Hobbister and Marwick Head. In other seasons, this species is common and widespread. Note that the American Herring Gull (*L. smithsonianus* in Europe and *L.a. Smithsonianus* in North America) should be looked for, particularly 1st year birds.

Iceland Gull, *Larus glaucoides*
Rare visitor
Found mainly in winter in small numbers in widespread locations.

Glaucous Gull, *Larus hyperboreus*
Uncommon visitor
Found mainly in winter in small numbers in widespread locations.

Great Black-backed Gull, *Larus marinus*
Common resident and breeder
Breed at Birsay Moor, Hobbister, The Loons, and North Hill. Widespread and easy to see in all seasons, look at Marwick Head, Noup Head, and Birsay.

Bridled Tern, *Sterna anaethetus*
Rare/Accidental
One record in 1979

Little Tern, *Sterna albifrons*
Rare breeder and passage migrant
There is an active breeding at Barrier #4. Small numbers may be seen in migration

Gull-billed Tern, *Sterna nilotica*
Rare/Accidental
Two records with the last in 1992

Caspian Tern, *Hydroprogne caspia*
Rare/Accidental
One record in 1998

Black Tern, *Chlidonias niger*
Rare/Accidental
Forty-three records with the last in 2012

White-winged Black Tern, *Chlidonias leucopterus*
Rare/Accidental
Fifteen records with the last in 2011

Sandwich Tern, *Sterna sandvicensis*
Uncommon breeder and rare winter visitor
Nests in very small numbers with recent attempts at Sanday and Papa Westray. Migrants are widespread but in small numbers.

Forster's Tern, *Sterna forsteri*
Rare/Accidental
One record in 2001

Common Tern, *Sterna hirundo*
Uncommon breeder
There is an active colony at Lyness in Hoy as well as recent breeding pairs at Hobbister Reserve.

Roseate Tern, *Sterna dougallii*
Rare/Accidental
Twelve records with the last in 2011. Three pairs may have bred in Sanday in 1969

Arctic Tern, *Sterna paradisaea*
Abundant breeder
Orkney has historically had significant large breeding colonies of this species but there have been huge declines in recent years. Some of the usual colonies are at Noup Head, North Hill, Craig Loch, Skipi Geo, Birsay and Hobbister. These and other colonies continued to suffer nesting failure in 2012. The exact reasons for these failures is not known but certainly changes in the supply of sandeels has to be suspected.

Alcidae, Auks

Common Guillemot/Murre, *Uria aalge*
Abundant breeder and passage migrant, fairly common in winter
There is a huge colony at Marwick Head which is easy and exciting to view. Additional colonies can be found at Noup Head, Fowl Craig, Copinsay, Sule Skerry and Sule Stack.

Brunnich's Guillemot/Thick-billed Murre, *Uria lomvia*
Rare/Accidental
Seven records with the last in 2001

Razorbill, *Alca torda*
Common breeder, uncommon in winter
There is a substantial easily viewed colony at Marwick Head and others at Fowls Craig, Noup Head, Muckle Skerry and Swona

Black Guillemot, *Cepphus grylle*
Common breeding resident
There is a good colony on Noup Head and birds can be seen throughout the islands, often fishing close to shore.

Little Auk/Dovekie, *Alle alle*
Fairly common migrant and winter visitor
Open Sounds like Scapa Flow are the favoured sites

Atlantic Puffin, *Fratercula arctica*
Abundant breeder, rare in winter
Sule Skerry is host to 60,000 breeding pairs but it is easier to view this species at Marwick Head, Birsay, and Castle O' Burrian (one of the best spots for photographers)

Pteroclididae, Sandgrouse

Pallas's Sandgrouse, *Syrrhaptes paradoxus*
Rare/Accidental
Thirteen records but none since 1888

Columbidae, Pigeons and Doves

Rock Dove, *Columba livia*
Common breeder
Wild breeding pairs can be found on the sea cliffs, Marwick Head is a good place to look.

Stock Dove, *Columba oenas*
Rare
Sixty records with the last in 2012

Woodpigeon, *Columba palumbus*
Common breeder, uncommon passage migrant
Breeding birds will be found in widespread localities, look at Binscarth Woods, Finstown and Kirkwall

Eurasian Collared Dove, *Streptopelia decaocto*
Common breeder and passage migrant
This species which can nest throughout much of the year, can be looked for in Finstown, Kirkwall, South Ronaldsay and North Ronaldsay

European Turtle Dove, *Streptopelia turtur*
Rare passage migrant
Small numbers are at widespread locations in migration with North Ronaldsay being a favoured location

Oriental/Rufous Turtle Dove, *Streptopelia orientalis*
Rare/Accidental
One record in 2002

Cuculidae, Cuckoos

Great Spotted Cuckoo, *Clamator glandarius*
Rare/Accidental
One record in 1959

Common Cuckoo, *Cuculus canorus*
Uncommon passage migrant, rare breeder
Breeding birds have been found in very low numbers in widespread locations, look in Rendall and Birsay

Yellow-billed Cuckoo, *Coccyzus americanus*
Rare/Accidental
Four records with the last in 2009

Tytonidae, Barn Owl

Barn Owl, *Tyto alba*
Rare/Accidental
Twenty-five records with the last in 2012. This species appears to becoming more successful in recent years.

Strigidae, Owls

Eurasian Scops Owl, *Otus scops*
Rare/Accidental
Seven records with the last in 1996

Snowy Owl, *Nyctea scandiaca*
Rare/Accidental
Thirty-three records with the last in 2009

Long-eared Owl, *Asio otus*
Rare breeder, uncommon migrant and winter visitor
Recent breeding records on the West Mainland. Migrant sightings are at widespread locations.

Short-eared Owl, *Asio flammeus*
Uncommon breeder and passage migrant
This species can be very visible when it is in the area. We watched one hunt along the Loch of Harray everyday for a few weeks in mid summer. The Birsay Moors are an excellent viewing location.

Tengmalm's Owl/Boreal Owl, *Aegolius funereus*
Rare/Accidental
Five records with the last in 1986

Caprimulgidae, Nighthawks and Nightjars

European Nightjar, *Caprimulgus europaeus*
Rare/Accidental
Thirty-nine records with the last in 2012

Common Nighthawk, *Chordeiles minor*
Rare/Accidental
One record in 1978

Apodidae, Swifts
White-throated Needletail, *Hirundapus caudacutus*
Rare/Accidental
Two records with the last in 1998

Alpine Swift, *Tachymarptis melba*
Rare/Accidental
Three records with the last in 2010

Common Swift, *Apus apus*
Uncommon passage migrant
Small numbers of migrants may be seen in widespread localities

Pallid Swift, *Apus pallidus*
Rare/Accidental
One record in 1996

Alcedinidae, Kingfisher

Common Kingfisher, *Alcedo atthis*
Rare/Accidental
Nine records with the last in 2001

Meropidae, Bee-Eater

European Bee-eater, *Merops apiaster*
Rare/Accidental
Nineteen records with the last in 2009

Coraciidae, Roller

European Roller, *Coracias garrulus*
Rare/Accidental
Twelve records with the last in 2012

Upupidae, Hoopoe

Common Hoopoe, *Upupa epops*
Rare
Sixty-nine records with the last in 2009

Picidae, Woodpeckers

Northern Wryneck, *Jynx torquilla*
Uncommon passage migrant
Small numbers is migration with North Ronaldsay being a favoured location.

Green Woodpecker, *Picus viridis*
Accidental
One record in 1885

Great Spotted Woodpecker, *Dendrocopos major*
Rare
Very small numbers are recorded in widespread locations in migration

Vireonidae, Vireo

Red-eyed Vireo, *Vireo olivaceus*
Rare/Accidental
One record in 2009

Oriolidae, Oriole

Eurasian Golden Oriole, *Oriolus oriolus*
Rare/Accidental
Seventy-six records with the last in 2012

Laniidae, Shrike

Isabelline Shrike, *Lanius isabellinus*
Rare/Accidental
Four records with the last in 2006

Red-backed Shrike, *Lanius collurio*
Rare passage migrant
Seen in most years with North Ronaldsay favoured.

Lesser Grey Shrike, *Lanius minor*
Rare/Accidental
Four records with the last in 2004

Great Grey Shrike/Northern Shrike, *Lanius excubitor*
Rare passage migrant
Recorded annually in migration usually in North Ronaldsay

Southern Grey Shrike, *Lanius meridionalis*
Rare/Accidental
Three records with the last in 2000

Woodchat Shrike, *Lanius senator*
Rare/Accidental
Twelve records with the last in 2012

Corvidae, Crows

Red-billed Chough, *Pyrrhocorax pyrrhocorax*
Rare/Accidental
Five records with the last in 2000

Common Magpie, *Pica pica*
Rare/Accidental
Thirteen records with the last in 2003

Eurasian Jay, *Garrulus glandarius*
Rare/Accidental
One record in 1967

Eurasian Nutcracker, *Nucifraga caryocatactes*
Rare/Accidental
One record in 1868

Eurasian Jackdaw, *Corvus monedula*
Common breeding resident
There are widespread locations for this species, look for it at Marwick Head, Birsay and Kirkwall.

Rook, *Corvus frugilegus*
Common breeding resident
A number of colonies mostly on the East Mainland include ones at Finstown, Tankerness, Kirkwall and Harray. Look in open fields near these area for flocks of birds.

Carrion Crow, *Corvus corone*
Occasional breeder and uncommon migrant
The rare breeding records often involve pairs with Hooded Crow. Most migration records are from North Ronaldsay.

Hooded Crow, *Corvus cornix*
Common resident breeder
Breeds in the RSPB Reserves of Loch of Banks, Cottascarth and Rendall Moss, Birsay Moors, Onziebust, and Hobbister. Ofter seen along the fences of farm fields.

Common Raven, *Corvus corax*
Fairly common breeder
There are breeding pairs in widespread localities. Look for them at sea cliffs like Marwick Head, Birsay Island, Noup Head and North Hill as well as quarries, buildings and man made towers.

Regulidae, Firecrest and Goldcrest

Firecrest, *Regulus ignicapilla*
Rare/Accidental
Twenty-three records with the last in 2012

Goldcrest, *Regulus regulus*
Rare breeder, common passage migrant
Small numbers of breeders with Hoy being favoured. Common passage migrant mainly in fall with records at scattered locations

Paridae, Tits

Blue Tit, *Parus caeruleus*
Rare
Forty-five records with the last in 2012

Great Tit, *Parus major*
Rare
Sixty-two records with the last in 2012

Coal Tit, *Parus ater*
Rare breeder
Forty records with the last in 2012. Breeding records from Hoy

Timaliidae, Bearded-Tit

Bearded Tit, *Panurus biarmicus*
Rare/Accidental
One record in 1998

Alaudidae, Larks

Calandra Lark, *Melanocorypha calandra*
Accidental
One record in 2002

Greater Short-toed Lark, *Calandrella brachydactyla*
Rare
Thirty-four records with the last in 2011

Woodlark, *Lullula arborea*
Accidental
Ten records with the last in 2011

Eurasian Skylark, *Alauda arvensis*
Common breeder, migrant and in winter
Breeding birds can be found on Birsay Moor, Brodgar, Onziebust, Cottascarth and Rendall Moss, Hobbister and North Hill.

Shore/Horned Lark, *Eremophila alpestris*
Rare
Forty-one records with the last in 2012

Hirundinidae, Swallows and Martins

Collared Sand Martin/Bank Swallow, *Riparia riparia*
Rare breeder and uncommon migrant
There are a few breeding colonies which seem to be on the increase. Look in South Ronaldsay especially in the Burray area.

Eurasian Crag Martin, *Ptyonoprogne rupestris*
Rare/Accidental
One record in 1999

Barn Swallow, *Hirundo rustica*
Rare breeder and uncommon migrant
Look for breeding birds at Onziebust, Marwick Head, as well as the Twatt Airfield in Birsay.

Northern House Martin, *Delichon urbicum*
Uncommon breeder and passage migrant
Small numbers of breeding sites. There is one in the eves of council flats in Dounby which has been there for many years as well as sites in Kirkwall, Evie and Stromness. It would seem to be increasing in numbers.

Red-rumped Swallow, *Cecropis daurica*
Rare/Accidental
Ten records with the last in 2012.

Aegithalidae, Long-tailed Tit

Long-tailed Tit, *Aegithalos caudatus*
Rare
Fifty-six records with the last in 2012

Sylviidae, Old World Warblers

Greenish Warbler, *Phylloscopus, trociloides*
Rare/Accidental
Eighteen records with the last in 2012

Arctic Warbler, *Phylloscopus borealis*
Rare/Accidental
Twenty-one records with the last in 2005

Pallas's Leaf Warbler, *Phylloscopus proregulus*
Rare/Accidental
Thirty-two records with the last in 2012

Yellow-browed Warbler, *Phylloscopus inornatus*
Uncommon fall passage migrant
Widespread records in small numbers

Hume's Leaf Warbler, *Phylloscopus humei*
Rare/Accidental
Two records with the last in 2008

Radde's Warbler, *Phylloscopus schwarzi*
Rare/Accidental
Seven records with the last in 1997

Dusky Warbler, *Phylloscopus fuscatus*
Rare/Accidental
Nine records with the last in 2011

Western Bonelli's Warbler, *Phylloscopus bonelli*
Rare/Accidental
Five records with the last in 2012
Note also there were an additional five records with the last in 2010 which are recorded as either Western Bonelli's Warbler or **Eastern Bonelli's Warbler**, *Phylloscopus orientalis*

Wood Warbler, *Phylloscopus sibilatrix*
Uncommon passage migrant
Small numbers in migration with most from North Ronaldsay

Common Chiffchaff, *Phylloscopus collybita*
Has bred, common passage migrant and occasional in winter
Records of this species are widespread in migration with good number from North Ronaldsay.

Willow Warbler, *Phylloscopus trochilus*
Uncommon breeder and common passage migrant
A small number of breeding pairs in wooded areas such as those on Hoy, Binscarth, Balfour Castle Wood and Trumland on Rousay.

Blackcap, *Sylvia atricapilla*
Has bred, Fairly common migrant and rare in winter
Most records in fall with Sanday and North Ronaldsay being favourites

Garden Warbler, *Sylvia borin*
Has bred, common passage migrant
Fair number during migration with most records from North Ronaldsay

Barred Warbler, *Sylvia nisoria*
Uncommon fall migrant
North Ronaldsay has the majority of records for this bird in Autumn

Lesser Whitethroat, *Sylvia curruca*
Has bred, uncommon passage migrant
The majority of records of this passage migrant are from North Ronaldsay.

Greater Whitethroat, *Sylvia communis*
Has bred, uncommon passage migrant
Widespread migrant records in small numbers with the majority recorded at North Ronaldsay

Subalpine Warbler, *Sylvia cantillans*
Rare
Twenty-one records with the last in 2011

Sardinian Warbler, *Sylvia melanocephala*
Rare/Accidental
Three records with the last in 1992

Lanceolated Warbler, *Locustella lanceolata*
Rare/Accidental
Six records with the last two in 2012.

Rusty-rumped/Pallas` Grasshopper Warbler, *Locustella certhiola*
Rare/Accidental
One record in 1992

Grasshopper Warbler, *Locustella naevia*
Has bred, rare passage migrant
Most records are from North Ronaldsay in migration

River Warbler, *Locustella fluviatilis*
Rare/Accidental
Three records with the last in 2012

Booted Warbler, *Iduna caligata*
Rare/Accidental
Three records with the last in 2012

Sykes's Warbler, *Iduna rama*
Rare/Accidental
Two records with the last in 2003

Icterine Warbler, *Hippolais icterina*
Has bred, rare passage migrant
Seen in very small numbers in most years with most sightings from North Ronaldsay

Melodious Warbler, *Hippolais polyglotta*
Rare/Accidental
Fourteen records with the last in 2003

Aquatic Warbler, *Acrocephalus paludicola*
Accidental
One record in 1999

Sedge Warbler, *Acrocephalus schoenobaenus*
Common breeder and migrant
Can be found at Cottascarth and Rendall Moss, Birsay Moor, Loch of Banks, Onziebust and Mill Dam

Paddyfield Warbler, *Acrocephalus agricola*
Rare/Accidental
Five records with the last in 2012

Blyth's Reed Warbler, *Acrocephalus dumetorum*
Rare/Accidental
Fourteen records with the last in 2012

Marsh Warbler, *Acrocephalus palustris*
Has bred, rare passage migrant
Eighty-three records including seven in 2012. Most records are from North Ronaldsay

Eurasian Reed Warbler, *Acrocephalus scirpaceus*
Uncommon passage migrant
Small numbers of migrants with North Ronaldsay having the most records

Great Reed Warbler, *Acrocephalus arundinaceus*
Rare/Accidental
Three records with the last in 2004

Bombycillidae, Waxwing

Bohemian Waxwing, *Bombycilla garrulus*
Irregular migrant and winter visitor
This irruptive species may be recorded in numbers or very uncommon. Localities are widespread.

Certhiidae, Treecreeper

Eurasian Treecreeper, *Certhia familiaris*
Rare
Thirty-five records with the last in 2012

Troglodytidae, Wren

Winter Wren, *Troglodytes troglodytes*
Common resident breeder
Found at the RSPB Reserves of Birsay Moors, Cottascarth, Hobbister and Loch of Banks. Finstown and Kirkwall are also preferred sites.

Sturnidae, Starlings

European Starling, *Sturnus vulgaris*
Common breeder, abundant in migration and winter
Breeds at places like North Hill and Birsay Moors. Flocks over 1,000 may be seen in passage and winter.

Rose-coloured Starling, *Sturnus roseus*
Rare/Accidental
Forty-three records with the last in 2010

Cinclidae, Dipper

White-throated Dipper, *Cinclus cinclus*
Has bred, rare
Twenty records with the last in 2012

Turdidae, Thrushes

White's Thrush, *Zoothera dauma*
Rare/Accidental
Three records with the last in 2012

Swainson's Thrush, *Catharus ustulatus*
Rare/Accidental
Two records with the last in 2011

Gray-cheeked Thrush, *Catharus minimus*
Rare/Accidental
Two records with the last in 2001

Veery, *Catharus fuscescens*
Rare/Accidental
One record in 2002

Siberian Thrush, *Zoothera sibirica*
Rare/Accidental
Three records with the last in 2012

Ring Ouzel, *Turdus torquatus*
Has bred, uncommon passage migrant
Very small numbers of scattered records in migration

Eurasian Blackbird, *Turdus merula*
Common resident breeder
Found breeding throughout the islands. Look in Hobbister, Cottascarth, Mill Dam, Loch of Banks, Finstown, Kirkwall and many other areas.

Eyebrowed Thrush, *Turdus obscurus*
Rare/Accidental
Two records with the last in 2009

Black-throated Thrush, *Turdus atrogularis*
Rare/Accidental
Four records with the last in 2010

Fieldfare, *Turdus pilaris*
Has bred, common migrant and fairly common winter visitor
Number vary but winter visitors and migrants are found in flocks throughout the islands.

Song Thrush, *Turdus philomelos*
Uncommon breeder, uncommon passage migrant
Breeds in various locations including Kirkwall, Finstown, Evie, Stromness and Hoy locations

Redwing, *Turdus iliacus*
Has bred, abundant in migration and common in winter
The last breeding record was in 2011. In migration large flocks may be found throughout the islands.

Mistle Thrush, *Turdus viscivorus*
Has bred, uncommon migrant
Small numbers seen in scattered locations in migration.

American Robin, *Turdus migratorius*
Rare/Accidental
One record in 1961

Muscicapidae, Old World Flycatchers

Spotted Flycatcher, *Muscicapa striata*
Has bred, uncommon migrant
Small numbers of migrants from widespread localities

European Robin, *Erithacus rubecula*
Uncommon breeding resident, common passage migrant
Found breeding in small numbers in scattered area like Finstown and Binscarth. Migrant numbers are variable but can be common.

Siberian Blue Robin, *Larvivora cyane*
Rare/Accidental
One record in 2001

Rufous-tailed Robin, *Larvivora sibilans*
Rare/Accidental
One record in 2010

Red-flanked Bluetail, Tarsinger *cyanura*
Rare/Accidental
Three records with the last in 2011

Bluethroat, *Luscinia svecica*
Uncommon migrant
Very small numbers in migration with the Northern Isles favoured.

Thrush Nightingale, *Luscinia luscinia*
Rare/Accidental
Seven records with the last in 2006

Common Nightingale, *Luscinia megarhynchos*
Very rare
Twelve records with the last in 2011

Red-breasted Flycatcher, *Ficedula parva*
Rare passage migrant
Very small numbers of migrants at varied locations

Collared Flycatcher, *Ficedula albicollis*
Rare/Accidental
Four records with the last in 2008

Pied Flycatcher, *Ficedula hypoleuca*
Uncommon passage migrant
Most records are from autumn migrants with North Ronaldsay a favoured location

Black Redstart, *Phoenicurus ochruros*
Has bred, uncommon passage migrant
Small numbers of migrants in widespread localities

Common Redstart, *Phoenicurus phoenicurus*
Common Passage migrant
Some numbers in migration with most records from North Ronaldsay

Common Rock Thrush, *Monticola saxatilis*
Rare/Accidental
One record in 1910

Whinchat, *Saxicola rubetra*
Has bred, common passage migrant
Some numbers of migrants in widespread localities

Siberian Stonechat, *Saxicola maurus*
Very rare
Seventeen records with the last in 2011

Common Stonechat, *Saxicola torquatus*
Fairly common breeding resident
Small numbers of breeding birds can be found at places like Birsay Moors, Hobbister and especially the Hoy Reserve.

Isabelline Wheatear, *Oenanthe isabellina*
Rare/Accidental
One record in 2005

Northern Wheatear, *Oenanthe oenanthe*
Fairly common breeder and migrant
Can be found at Marwick Head, the Bay of Skaill, Yesnaby, Warebeth Bay near Stromness and North Hill.

Pied Wheatear, *Oenanthe pleschanka*
Rare/Accidental
Seven records with the last in 2010

Desert Wheatear, *Oenanthe deserti*
Rare/Accidental
Three records with the last in 2011

Prunellidae, Dunnock

Dunnock, *Prunella modularis*
Uncommon breeding resident and passage migrant
Breeding birds may be found in Kirkwall, Finstown, Stromness and parts of Hoy.

Passeridae, House Sparrows

House Sparrow, *Passer domesticus*
Common breeding resident
Look for in Kirkwall, Finstown, Stromness and many other widespread localities.

Spanish Sparrow, *Passer hispaniolensis*
Rare/Accidental
One record in 1993

Eurasian Tree Sparrow, *Passer montanus*
Has bred, rare
Small numbers in scattered localities and different seasons.

Motacillidae, Pipits and Wagtails

Yellow Wagtail, *Motacilla flava*
Uncommon passage migrant
Small number of migrants record favouring North Ronaldsay

Citrine Wagtail, *Motacilla citreola*
Rare/Accidental
Eighteen records with the last in 2012

Grey Wagtail, *Motacilla cinerea*
Occasional breeder, uncommon in all seasons
Small numbers may be found in scattered locations in any season

White/Pied Wagtail, *Motacilla alba*
Fairly common breeder, rare winter visitor
Found in widespread localities Look for at Brodgar, North Hill and any ruined crofts or stone dykes.

Richard's Pipit, *Anthus richardi*
Rare
Seventy-nine records with the last in 2012.

Tawny Pipit, *Anthus campestris*
Rare/Accidental
Four records with the last in 2011

Olive-backed Pipit, *Anthus hodgsoni*
Rare/Accidental
Twenty-five records with the last in 2012

Tree Pipit, *Anthus trivialis*
Uncommon passage migrant
Small numbers of migrants with most records from North Ronaldsay

Pechora Pipit, *Anthus gustavi*
Rare/Accidental
Three records with the last in 2011

Meadow Pipit, *Anthus pratensis*
Abundant breeder, uncommon in winter
Breeding birds will be found in the RSPB Reserves of Loch of Banks, Birsay Moors, Cottascarth, Brodgar, The Loons, Hobbister, Onziebust, Copinsay and North Hill as well as Marwick Head, Skaill, Birsay and Yesnaby

Red-throated Pipit, *Anthus cervinus*
Rare/Accidental
Seventeen records with the last in 1999

Rock Pipit, *Anthus petrosus*
Common breeding resident
Breeding birds found in the RSPB Reserves of Copinsay, Marwick Head and North Hill. Look also at Skaill and Yesnaby.

Water Pipit, *Anthus spinoletta*
Rare/Accidental
Two records with the last in 1996

Buff-bellied Pipit, *Anthus rubescens*
Rare/Accidental
Three records with the last in 2011

Fringillidae, Finches

Chaffinch, *Fringilla coelebs*
Uncommon resident breeder
Breeding birds may be found on Hoy and scattered West mainland sites

Brambling, *Fringilla montifringilla*
Has bred, common passage migrant, uncommon winter visitor
Sightings of migrants from scattered sites throughout.

European Greenfinch, *Carduelis chloris*
Common breeder and passage migrant
Look for birds in Kirkwall, Finstown and Evie as well as other scattered locations.

European Goldfinch, *Carduelis carduelis*
Has bred, uncommon in all seasons
There have been recent breeding records including Finstown in 2011. They are often found there in winter as well.

Eurasian Siskin, *Carduelis spinus*
Has bred, common migrant
Scattered records of migrants at widespread locations.

Common Linnet, *Carduelis cannabina*
Fairly common breeder and passage migrant and winter visitor
Found in the RSPB Reserves of Brodgar and Loch of Banks as well as other scattered sites. Increasing winter records.

Twite, *Carduelis flavirostris*
Fairly common breeding resident
Found in the RSPB Reserves of Birsay Moors, Hobbister, Copinsay, Cottascarth, The Loons, North Hill and Onziebust.

Lesser Redpoll, *Carduelis cabaret*
Occasional breeder and uncommon passage migrant
Small numbers in migration are recorded in scattered locations.

Common Redpoll, *Carduelis flammea*
Has bred, uncommon passage migrant
Found in scattered locations as a migrant

Hoary Redpoll, *Carduelis hornemanni*
Rare/Accidental
9 records with the last in 2012

White-winged/Two-barred Crossbill, *Loxia leucoptera*
Rare/Accidental
Fourteen records with the last in 2008

Common/Red Crossbill, *Loxia curvirostra*
Uncommon except in irruption years
In most years there are a few records mainly in migration from scattered locations.

Parrot Crossbill, *Loxia pytyopsittacus*
Rare/Accidental
Three records with the last in 1985

Trumpeter Finch, *Bucanetes githagineus*
Rare/Accidental
One record in 1981

Common Rosefinch, *Carpodacus erythrinus*
Uncommon passage migrant
Migrants seen mainly in autumn with North Ronaldsay favoured

Eurasian Bullfinch, *Pyrrhula pyrrhula*
Uncommon
Small numbers of records mainly in migration from scattered locations

Hawfinch, *Coccothraustes coccothraustes*
Rare
Small numbers of sightings in scattered locations primarily in migration.

Emberizidae, Buntings and Sparrows

Snow Bunting, *Plectrophenax nivalis*
Common passage migrant and winter visitor
In migration and winter flocks of this species may be found throughout the islands

Lapland Longspur/Bunting, *Calcarius lapponicus*
Uncommon passage migrant
Records of migrants recorded in various locations annually particularly in North Ronaldsay

Rose-breasted Grosbeak, *Pheucticus ludovicianus*
Accidental
One record, an immature male was recorded Oct 10/2011

White-throated Sparrow, *Zonotrichia albicollis*
Rare/Accidental
One record in 1996

Pine Bunting, *Emberiza leucocephalos*
Rare/Accidental
Ten records with the last in 1995

Yellowhammer, *Emberiza citrinella*
Formerly bred, rare
A few scattered records in migration with most in the fall. It may have been a regular breeding species in the 19th century

Cirl Bunting, *Emberiza cirlus*
Rare/Accidental
Three records with the last in 2003

Ortolan Bunting, *Emberiza hortulana*
Rare
Fifty-four records with the last in 2012

Cretzschmar's Bunting, *Emberiza caesia*
Rare/Accidental
Two records with the last in 2008

Yellow-browed Bunting, *Emberiza chrysophrys*
Rare/Accidental
Two records with the last in 1998

Rustic Bunting, *Emberiza rustica*
Rare/Accidental
Thirty-one records with the last in 2012

Little Bunting, *Emberiza pusilla*
Rare
Eighty-six records with the last in 2012.

Yellow-breasted Bunting, *Emberiza aureola*
Rare/Accidental
Nine records with the last in 2003

Reed Bunting, *Emberiza schoeniclus*
Fairly common breeder and passage migrant
Breeding birds may be found in the RSPB Reserves of Birsay Moors, Loch of Banks

Black-headed Bunting, *Emberiza melanocephala*
Rare/Accidental
Twelve records with the last in 2012

Corn Bunting, *Emberiza calandra*
Rare
This species was very common in the 19th century but has declined to the point that is not recorded in some years as was the case in 2011

Parulidae, New World Warblers

Tennessee Warbler, *Vermivora peregrina*
Rare/Accidental
One record in 1982

Yellow Warbler, *Dendroica petechia*
Rare/Accidental
One record in 1992

Yellow-rumped Warbler, *Dendroica coronata*
Rare/Accidental
Two records with the last in 2003

Bibliography

Orkney Bird Report 1974-2012

Islands of Birds, Edward Meek, 1985, RSPB

The Shore-Birds of the Orkney Islands, Tay and Orkney Ringing Group, 1984

The Birds of Orkney, Booth, Cuthbert and Reynolds, 1984, Orkney Press

The Atlas of Breeding Birds in Britain and Ireland, J.T.R. Sharrock (Editor) ,1976, Pub. T. & A.D. Poyser

Birds and Mammals of Orkney, Groundwater, 1974, Kirkwall Press

Orkney Birds: Status and Guide, Balfour, 1972

Breeding Birds of Orkney, Balfour, 1968, Scottish Birds

Index

Albatross, Black-browed	58
Auk, Little	88
Avocet, Pied	70
Bee-eater, European	94
Bittern, Eurasian	61
Bittern, Little	61
Blackbird, Eurasian	107
Blackcap	102
Bluetail, Red-flanked	110
Bluethroat	110
Brambling	116
Bullfinch, Eurasian	119
Bunting, Black-headed	122
Bunting, Cirl	120
Bunting, Corn	122
Bunting, Cretzschmar's	121
Bunting, Lapland	119
Bunting, Little	121
Bunting, Ortolan	121
Bunting, Pine	120
Bunting, Reed	121
Bunting, Rustic	121
Bunting, Snow	119
Bunting, Yellow-breasted	121
Bunting, Yellow-browed	121
Bustard, Great	70
Bustard, Little	70
Buzzard, Eurasian	66
Buzzard, European Honey	64
Buzzard, Rough-legged	66
Canvasback	52
Chaffinch	116
Chiffchaff, Common	102
Chough, Red-billed	96
Coot, Common	69

Cormorant, Great	60
Corncrake	69
Crake, Spotted	68
Crane, Common	70
Crane, Sandhill	70
Crossbill, Common	118
Crossbill, Parrot	119
Crossbill, Red	118
Crossbill, Two-barred	118
Crossbill, White-winged	118
Crow, Carrion	97
Crow, Hooded	97
Cuckoo, Common	91
Cuckoo, Great Spotted	91
Cuckoo, Yellow-billed	91
Curlew, Eurasian	77
Dipper, White-throated	107
Diver, Black-throated	57
Diver, Common	57
Diver, Red-throated	57
Diver, Yellow-billed	58
Dotterel, Eurasian	72
Dove, Eurasian Collared	90
Dove, European Turtle	90
Dove, Oriental	91
Dove, Rock	89
Dove, Rufous Turtle	91
Dove, Stock	90
Dovekie	88
Dowitcher, Long-billed	77
Duck, Ferruginous	53
Duck, Long-tailed	54
Duck, Mandarin	49
Duck, Ring-necked	52
Duck, Ruddy	55
Duck, Tufted	53
Dunlin	75

Dunnock	112
Eagle, Golden	66
Eagle, White-tailed Sea	64
Egret, Great	62
Egret, Little	61
Eider, Common	54
Eider, King	54
Eider, Steller's	54
Falcon, Peregrine	68
Falcon, Red-footed	67
Fieldfare	108
Finch, Trumpeter	119
Firecrest	98
Flycatcher, Collared	110
Flycatcher, Pied	111
Flycatcher, Red-breasted	110
Flycatcher, Spotted	109
Fulmar, Northern	58
Gadwall	50
Gannet, Northern	60
Garganey	52
Godwit, Bar-tailed	77
Godwit, Black-tailed	77
Goldcrest	98
Goldeneye, Common	55
Goldfinch, European	117
Goosander	55
Goose, Barnacle	48
Goose, Bean	47
Goose, Brent/Brant	48
Goose, Canada	48
Goose, Egyptian	48
Goose, Greater White-fronted	47
Goose, Greylag	48
Goose, Pink-footed	47
Goose, Snow	48
Goshawk, Northern	65

Grebe, Black-necked/Eared	64
Grebe, Great Crested	63
Grebe, Horned	64
Grebe, Little	63
Grebe, Red-necked	63
Grebe, Slavonian	64
Greenfinch, European	116
Greenshank, Common	79
Grosbeak, Rose-breasted	120
Grouse, Eurasian Black	56
Grouse, Red	56
Grouse, Willow	56
Guillemot, Black	88
Guillemot, Brunnich's	88
Guillemot, Common	87
Gull, Bonaparte's	82
Gull, Common Black-headed	83
Gull, European Herring	84
Gull, Glaucous	85
Gull, Great Black-backed	85
Gull, Iceland	84
Gull, Ivory	82
Gull, Laughing	83
Gull, Lesser Black-backed	84
Gull, Little	83
Gull, Mediterranean	84
Gull, Mew/Common	84
Gull, Ring-billed	84
Gull, Ross's	83
Gull, Sabine's	82
Gyrfalcon	67
Harrier, Montagu's	65
Harrier, Hen	64
Harrier, Northern	64
Harrier, Pallid	65
Harrier, Western Marsh	65
Hawfinch	119

Heron, Great Blue-winged	62
Heron, Grey	62
Heron, Purple	62
Heron, Squacco	61
Hobby, Eurasian	67
Hoopoe, Common	94
Ibis, Glossy	63
Jackdaw, Eurasian	96
Jaeger, Long-tailed	82
Jaeger, Parasitic	82
Jaeger, Pomarine	81
Jay, Eurasian	96
Kestrel, Common	67
Kestrel, Lesser	67
Kingfisher, Common	94
Kite, Black	64
Kite, Red	64
Kittiwake, Black-legged	82
Knot, Red	73
Lapwing, Northern	73
Lark, Calandra	99
Lark, Greater Short-toed	99
Lark, Horned	100
Lark, Shore	100
Linnet, Common	117
Longspur, Lapland	119
Loon, Black-throated	57
Loon, Great Northern	57
Loon, Red-throated	57
Loon, Yellow-billed	58
Magpie, Common	96
Mallard	51
Martin, Collared Sand	100
Martin, Eurasian Crag	100
Martin, Northern House	100
Merganser, Red-breasted	55
Merganser, Common	55

Merlin	67
Moorhen, Common	69
Murre, Common	87
Murre, Thick-billed	88
Needletail, White-throated	93
Night Heron, Black-crowned	61
Nighthawk, Common	93
Nightingale, Common	110
Nightingale, Thrush	110
Nightjar, European	92
Nutcracker, Eurasian	96
Oriole, Eurasian Golden	95
Osprey	67
Ouzel, Ring	107
Owl, Barn	91
Owl, Boreal	92
Owl, Eurasian Scops	91
Owl, Long-eared	92
Owl, Short-eared	92
Owl, Snowy	91
Owl, Tengmalm's	92
Oystercatcher, Eurasian	70
Partridge, Grey	56
Partridge, Red-legged	56
Petrel, Cape Verde	59
Petrel, Fea's	59
Petrel, Zino's	59
Phalarope, Grey/Red	80
Phalarope, Red-necked	80
Phalarope, Wilson's	80
Pheasant, Common	56
Pintail, Northern	52
Pipit, Buff-bellied	116
Pipit, Meadow	115
Pipit, Olive-backed	114
Pipit, Pechora	114
Pipit, Red-throated	115

Pipit, Richard's	114
Pipit, Rock	115
Pipit, Tawny	114
Pipit, Tree	114
Pipit, Water	115
Plover, American Golden	72
Plover, Black-bellied	72
Plover, Common Ringed	72
Plover, Eurasian Golden	72
Plover, Greater Sand	72
Plover, Grey	72
Plover, Little Ringed	71
Plover, Pacific Golden	72
Plover, Sociable	72
Pochard, Common	52
Pochard, Red-crested	52
Pratincole, Collared	71
Ptarmigan, Rock	56
Puffin, Atlantic	89
Quail, Common	56
Rail, Water	68
Raven, Common	98
Razorbill	88
Redpoll, Common	118
Redpoll, Hoary	118
Redpoll, Lesser	118
Redshank, Common	79
Redshank, Spotted	79
Redstart, Black	111
Redstart, Common	111
Redwing	109
Robin, American	109
Robin, European	110
Robin, Rufous-tailed	110
Robin, Siberian Blue	110
Roller, European	94
Rook	97

Rosefinch, Common	119
Ruff	76
Sanderling	73
Sandgrouse, Pallas's	89
Sandpiper, Baird's	74
Sandpiper, Broad-billed	75
Sandpiper, Buff-breasted	76
Sandpiper, Common	78
Sandpiper, Curlew	75
Sandpiper, Green	78
Sandpiper, Marsh	79
Sandpiper, Pectoral	74
Sandpiper, Purple	75
Sandpiper, Semipalmated	74
Sandpiper, Sharp-tailed	74
Sandpiper, Spotted	78
Sandpiper, Terek	78
Sandpiper, Western	74
Sandpiper, White-rumped	74
Sandpiper, Wood	79
Scaup, Greater	53
Scaup, Lesser	53
Scoter, Common	55
Scoter, Surf	55
Scoter, Velvet	55
Shag, European	60
Shearwater, Balearic	59
Shearwater, Cory's	59
Shearwater, Great	59
Shearwater, Manx	59
Shearwater, Sooty	59
Shelduck, Common	49
Shelduck, Ruddy	49
Shoveler, Northern	52
Shrike, Great Grey	95
Shrike, Isabelline	95
Shrike, Lesser Grey	95

Shrike, Northern	95
Shrike, Red-backed	95
Shrike, Southern Grey	96
Shrike, Woodchat	96
Siskin, Eurasian	117
Skua, Great	81
Skua, Arctic	82
Skua, Long-tailed	82
Skua, Pomarine	81
Skylark, Eurasian	99
Smew	55
Snipe, Common	76
Snipe, Great	77
Snipe, Jack	76
Sparrow, Eurasian Tree	113
Sparrow, House	113
Sparrow, Spanish	113
Sparrow, White-throated	120
Sparrowhawk, Eurasian	66
Spoonbill, Eurasian	63
Starling, European	106
Starling, Rose-coloured	106
Stilt, Black-winged	70
Stint, Little	74
Stint, Temminck's	74
Stone Curlew, Eurasian	71
Stonechat, Common	111
Stonechat, Siberian	111
Stork, Black	63
Stork, European White	63
Storm Petrel, European	60
Storm Petrel, Leach's	60
Swallow, Bank	100
Swallow, Barn	100
Swallow, Red-rumped	100
Swan, Bewick's	46
Swan, Mute	46

Swan, Tundra	46
Swan, Whooper	46
Swift, Alpine	93
Swift, Common	93
Swift, Pallid	93
Teal, Blue-winged	52
Teal, Common	51
Teal, Green-winged	51
Tern, Arctic	87
Tern, Black	86
Tern, Bridled	85
Tern, Caspian	86
Tern, Common	87
Tern, Forster's	87
Tern, Gull-billed	86
Tern, Little	85
Tern, Roseate	87
Tern, Sandwich	86
Tern, White-winged Black	86
Thrush, Black-throated	108
Thrush, Common Rock	111
Thrush, Eyebrowed	108
Thrush, Gray-cheeked	107
Thrush, Mistle	109
Thrush, Siberian	107
Thrush, Song	108
Thrush, Swainson's	107
Thrush, White's	107
Tit, Bearded	98
Tit, Blue	98
Tit, Coal	98
Tit, Great	98
Tit, Long-tailed	100
Treecreeper, Eurasian	105
Turnstone, Ruddy	79
Twite	117
Veery	107

Vireo, Red-eyed	95
Wagtail, Citrine	114
Wagtail, Grey	114
Wagtail, Pied	114
Wagtail, White	114
Wagtail, Yellow	113
Warbler, Aquatic	104
Warbler, Arctic	101
Warbler, Barred	102
Warbler, Blyth's Reed	105
Warbler, Booted	103
Warbler, Dusky	101
Warbler, Eurasian Reed	105
Warbler, Garden	102
Warbler, Grasshopper	103
Warbler, Great Reed	105
Warbler, Greenish	101
Warbler, Hume's Leaf	101
Warbler, Icterine	104
Warbler, Lanceolated	103
Warbler, Marsh	105
Warbler, Melodious	104
Warbler, Paddyfield	105
Warbler, Pallas's Grasshopper	103
Warbler, Pallas's Leaf	101
Warbler, Radde's	101
Warbler, River	103
Warbler, Rusty-rumped	103
Warbler, Sardinian	103
Warbler, Sedge	104
Warbler, Sykes's	103
Warbler, Subalpine	103
Warbler, Tennessee	122
Warbler, Western Bonelli's	101
Warbler, Willow	102
Warbler, Wood	102
Warbler, Yellow	122

Warbler, Yellow-browed	101
Warbler, Yellow-rumped	123
Waxwing, Bohemian	105
Wheatear, Desert	112
Wheatear, Isabelline	111
Wheatear, Northern	112
Wheatear, Pied	112
Whimbrel	77
Whinchat	111
Whitethroat, Greater	103
Whitethroat, Lesser	102
Wigeon, American	50
Wigeon, Eurasian	50
Woodcock, Eurasian	77
Woodlark	99
Woodpecker, Great Spotted	95
Woodpecker, Green	94
Woodpigeon	90
Wren, Winter	106
Wryneck, Northern	94
Yellowhammer	120
Yellowlegs, Lesser	79

Lightning Source UK Ltd.
Milton Keynes UK
UKHW021145110821
388616UK00007B/95